EAST END CEMETERIES

BRADY STREET & ALDERNEY ROAD

LOUIS BERK

AMBERLEY

First published 2017

Amberley Publishing
The Hill, Stroud
Gloucestershire, GL5 4EP

www.amberley-books.com

British Library Cataloguing in Publication Data.
A catalogue record for this book is available from the British Library.

ISBN 978 1 4456 6290 9 (print)
ISBN 978 1 4456 6291 6 (ebook)

Origination by Amberley Publishing.
Printed in Great Britain.

FOREWORD

In July 2004 I took up a teaching post in Whitechapel, in the East End of London. This has become a highly significant stage in my life, as I began to explore the remarkable environment I came to work in.

The social history contained within this one small area is among some of the most important and fascinating of the last 200 years in London (possibly in the whole of the UK).

My school in Whitechapel is nearly 100 per cent Bangladeshi, reflecting the current dominant ethnic group. There is little sense today of the large and significant Jewish community that lived in the area until shortly after the Second World War. The East End has seen many immigrant communities come and go.

One day I was looking out of a top-floor window on the north side of my school when I saw an amazing sight. Over the high walls I could see into what was unmistakably a Jewish cemetery. My interest may have finished there: I had no links to the cemetery and didn't think I would be granted entrance. A few months later, in August 2005, I was in the school preparing for the new term. Looking out of the window, I noticed workmen busy in the cemetery and I took that opportunity to walk over and ask one of the groundsmen to let me have a look around.

It was as though I had entered a country forest in the middle of Whitechapel, complete with a fox that loped down a path ahead of me. Grabbing my camera, I took photographs of headstones with intricate carvings as I wandered beneath the cool green canopy overhead. The seed of an idea began to grow in my mind. How brilliant it would be to capture the natural wonder of this oasis in the city in photography.

It would be another five years before I took my idea forward. I can't now recall the reason why, but in May 2010 I contacted Melvyn Hartog at the United Synagogue. How would he respond to my curious request to undertake a photographic study of the Brady Street cemetery? To my delight, Melvyn's reply was quick and positive, and he generously agreed to allow me complete access to the cemetery whenever I liked. Now my project could be developed over time, without any restrictions.

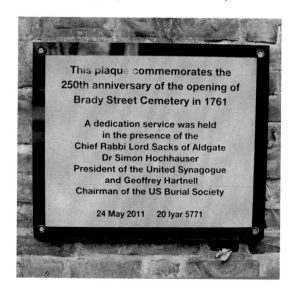

EAST END JEWISH CEMETERIES

I began photographing in August 2011 and continued through all weathers and seasons until July 2016. My purpose was not to make a historical document of the headstones in the Brady Street Jewish cemetery. My approach was that of a landscape photographer. I wanted to communicate the unique natural beauty of a mixed forest with its own ecosystem in the centre of Whitechapel.

The cemetery was opened in 1761 and was probably quite well maintained until its closure less than a hundred years later. Since then, nature has slowly been winning its way back into this environment. In a hundred years from now, the centre of the cemetery may largely be a natural forest. What a marvellous legacy that would be for future inhabitants of Whitechapel. My hope is that this book is part of that legacy.

Apart from the cemetery fox, while photographing in Brady Street I have also observed a group of squirrels, as well as a large number of blackbirds, songbirds and woodpeckers, who all thrive in the shrubs and trees. In spring, the cemetery becomes a riot of wild flowers and grasses.

I have had the unique opportunity to take my camera into Brady Street for over five years and record the changing seasons and their effect on the cemetery. My photos also show the connection of the cemetery to the surrounding area, including the large yellow 'shotcrete' towers of the current Crossrail construction, the landmark architecture of the Square Mile and various examples of local authority housing that surround the site.

Once I showed Melvyn the fruits of my first year of photographing Brady Street, he asked me if I would photograph the even older Jewish cemetery of Alderney Road. This is included as an addendum to the central work.

I have enormously enjoyed the privilege of photographing in both cemeteries and wish to respect the wishes of any individuals connected with the cemetery. As such, should anyone contact me asking that headstones of their relatives not be included in future editions of this work, this will be arranged.

My intention remains to celebrate the unique natural environment of Brady Street and Alderney Road cemeteries and also to remind us of the ephemeral nature of human life when seen against the changing backdrop that signifies our civilisation.

Louis Berk
January 2017

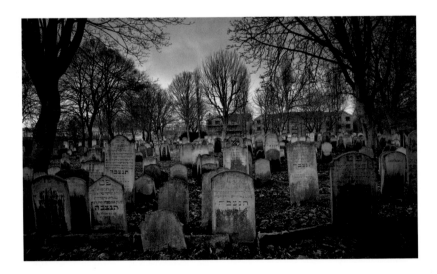

INTRODUCTION TO BRADY STREET CEMETERY BY RACHEL KOLSKY

If you turn off the Whitechapel Road at the green-blue glass building, which is one of Tower Hamlets' Ideas Stores, you leave the bustling, noisy Bengali street market selling fruit, vegetables and huge frozen fish and enter a quiet road called Brady Street, once Ducking Pond Lane and later North Street. After passing a school and small block of flats dating from 1905 – Mocatta House – you will walk alongside a plain brick wall, one that gives no indication as to what lies behind. Shortly afterwards, you will turn to the left and there is a gate – through the ironwork you will see one of London's hidden treasures, Brady Street Jewish Cemetery. Despite the proximity of the ever-growing number of apartment blocks now surrounding two sides of the cemetery, it remains a haven of tranquillity.

Opened in 1761 and closed in 1858, Brady Street cemetery covers a period of great change for the Jewish community, which, following a period of exile from 1290, resettled in the UK in 1656, courtesy of Oliver Cromwell. When the cemetery opened, there was no umbrella synagogual body

EAST END JEWISH CEMETERIES

for Ashkenazi Jews; each separate synagogue opened its own cemetery. Members of the Jewish community were denied high civic office but, by the time of closure, the first Jewish Lord Mayor of London, David Salomons (in 1855), and the first official Jewish MP, Lionel de Rothschild (in 1858), had been elected. As such, the history of the cemetery at Brady Street can be seen as part of the story of the Anglo-Jewish community itself.

The first recorded London cemetery for pre-expulsion Jewry was situated near Moorgate and until 1177 it was the only one in England. No other Jewish burial grounds were evident in London until the resettlement, when both the Sephardi and Ashkenazi communities opened cemeteries in Mile End, then a green rural area filled with fields and orchards. The Sephardi cemeteries, both now within the grounds of Queen Mary College, were opened in 1656 and 1733. The first Ashkenazi cemetery was established in 1696, nearby in Alderney Road, by the Great Synagogue of Dukes Place. In 1761, the New Synagogue opened its cemetery in Brady Street; followed in 1788 by the Hambro Synagogue, which opened its cemetery in Hackney, at Lauritson Road. In 1811, the breakaway Western Synagogue, in the West End, added its cemetery to the area, in Bancroft Road.

When the New Synagogue was formed, land was immediately leased for its cemetery. A site was found in Brady Street, for 12 guineas per annum, and the freehold was purchased in 1795. By the 1840s, the cemetery was filling up and, with no opportunity to expand the site, a 4-foot-deep layer of earth was added to enable double-decker burials. Visiting the cemetery today, this raised central mound is very evident and several back-to-back tombstones remain standing.

The decoration of the tombstones provides a fascinating insight into the community of the late 1700s and early 1800s, including the use of the symbols of praying hands, denoting a cohen (priest), and the pitcher of water denoting the Levis, who wash the hands of the Cohanim. Fish and books are also in great abundance and it is often said that these represent a fishmonger and a scholar. Prevalent centuries ago, but not now considered appropriate, are the addresses of the deceased – for example, Leman Street and Upper Gower Street. One imagines that families were proud of their journey to a new home and reaching the giddy heights of Bloomsbury.

The grave of Miriam Levy (1805–1855) mentions her address as Ladbroke Terrace, Notting Hill. Very unusually, it also includes images of her face as a relief around the sides. Despite no written evidence, it is believed that she was a social worker who opened one of the first soup kitchens for the Jewish poor.

Also buried here is one of the early religious leaders of Anglo-Jewry, Solomon Hirschel (1762–1842), rabbi of the Great Synagogue between 1802 and 1842. He was instrumental in greater co-operation between the three main Ashkenazi communities in London.

Hyman Hurwitz (1770–1844) is commemorated by a tall obelisk. Born in Poland, he arrived in the UK in his twenties and, from 1799, ran a boys' school in Highgate, at No. 10 South Grove – the building still stands today, as a private home. In 1826, Abraham Goldscmid, a benefactor of the new nonconformist University College, petitioned to establish a Chair of Hebrew Language and Literature and, in 1828, Hurwitz was offered the position.

Close to the Hurwitz memorial, in a small enclosure, are two white-marble chest tombs. Although plain, the names are immediately recognisable – that of Nathan Mayer Rothschild (1777–1836) and his widow, Hannah (1783–1850). Nathan Mayer arrived in England from Germany in 1798 and after a short time in Manchester, established his finance house in St Swithin's Lane in the City of London. He married Hannah Cohen, whose sister Judith married Moses Montefiore, the famous financier and philanthropist. Nathan Mayer Rothschild died in Germany while attending the wedding of his son, Lionel, but his wish was to be buried in England. The funeral procession of

seventy-five carriages from his town house in Piccadilly to east London is testament to the respect accorded to him. Following his death, his widow encouraged their children to succeed in business, enjoy society, embrace the country life with mansions and racehorses and continue the family philanthropy in both the Jewish and secular worlds. It was their son, Lionel, who became the first official Jewish MP in 1858 and their grandson, Nathaniel, who became the first Jewish Lord in 1885.

By 1856 no further burials were being arranged and in 1858 the cemetery was closed. Several reasons account for this, including the rapid urbanisation of Mile End and Stepney and the considerable growth of the Jewish population, requiring more synagogues and larger cemeteries. In addition, West Ham cemetery, further east, was opened in 1856 as a joint initiative between the Great and New Synagogues. This was a precursor to co-operation between the Ashkenazi congregations, which resulted in the formation of the United Synagogue in 1870 as an umbrella body for five founding synagogues. Not long afterwards, in 1873, the Willesden Jewish cemetery was opened under the auspices of the United Synagogue, and this became the resting place of choice for the Anglo-Jewish elite.

However, when you look again at the enclosure for N. M. and Hannah Rothschild, you see next to it a large, red-granite chest tomb – but one with no indication of who lies within, no markings or decoration. This is the final resting place of Victor, 3rd Baron Rothschild (1910–1990). In 1937 Victor became Lord Rothschild, following the death of his uncle, Walter, the 2nd Baron Rothschild, who died without an heir. Victor was multitalented, a biologist who also had an avid interest in jazz and cricket. He was also a member of Margaret Thatcher's Think Tank and head of the eponymous family bank. Despite Judaism not playing an active role in his life, he requested a Jewish burial alongside his ancestors and the privy chamber made special arrangements for the burial to take place, despite Brady Street having previously been closed for over 100 years.

Today, the cemetery is very much a nature reserve with several important trees such as a Japanese Red Pine, one of only two known in London. Birds and winged creatures enjoy the secluded surroundings, but it is also an important historic site. Just inside the gate there is a plaque dated 2011, the 250th anniversary of the cemetery, the significance of which was recognised by the presence at the commemorative service of the then Chief Rabbi, Lord Sacks.

Rachel Kolsky is a popular and well-regarded London Blue Badge Tour Guide (www.golondontours.com). Passionate about exploring Jewish heritage and the East End, she is the co-author of Jewish London *and* Whitechapel in 50 Buildings.

LATE SUMMER

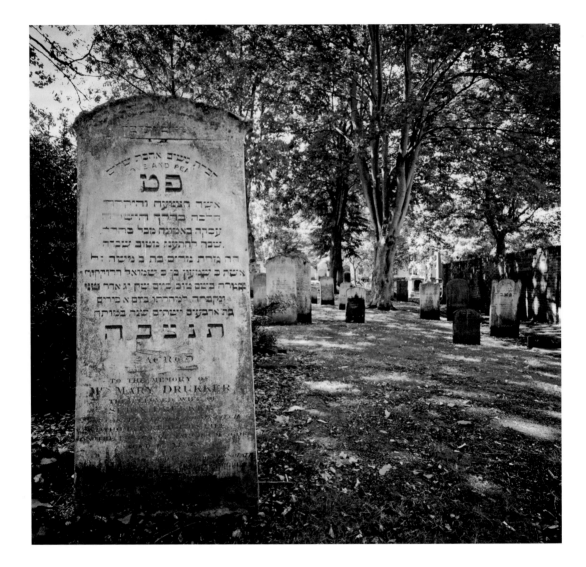

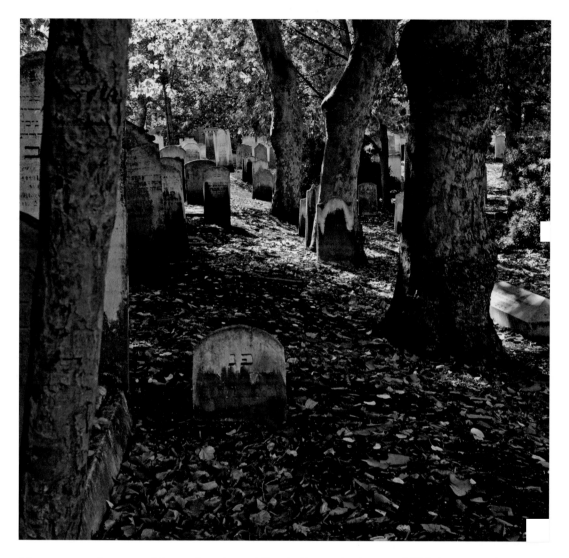

I began my photographic exploration of Brady Street in August 2011. It was a dry, warm summer and the canopy was in full leaf, creating pools of light and shade. Deep inside the canopy, I can imagine I am in a forest and not in one of the most densely inhabited parts of Greater London.

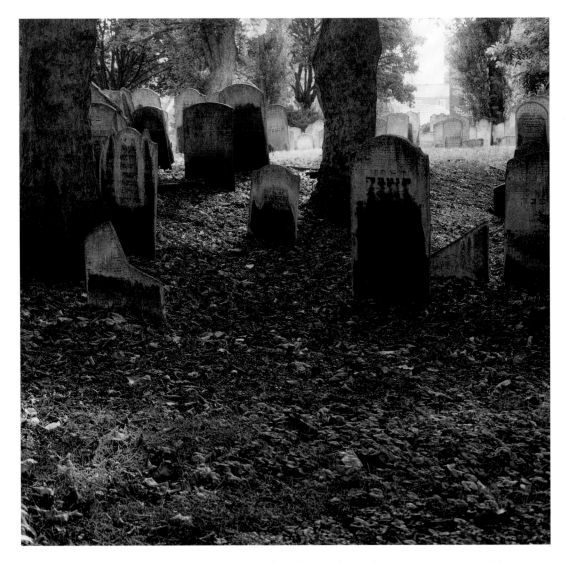

The gentle rise in the ground was created in the 1840s when a second burial level was placed on top of the original land to increase the capacity of the cemetery. On the ground are the leaves that fell last autumn and have remained undisturbed all through winter and spring.

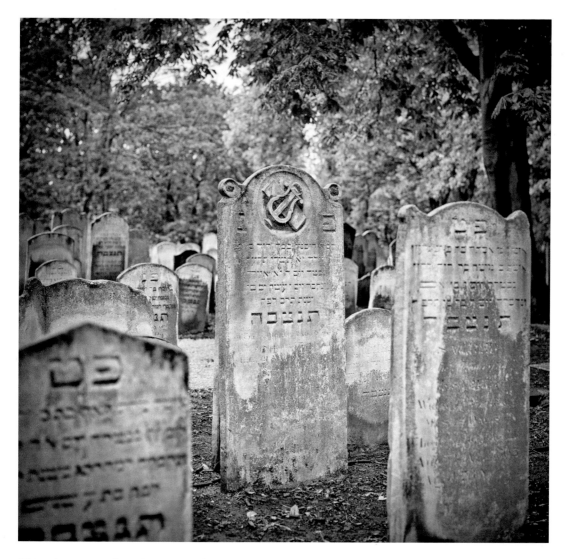

This distinctive headstone in the central raised area may signify the resting place of a musician. The date has been eroded from the face of the headstone but it must be one of the later burials, just before the cemetery finally closed in 1858.

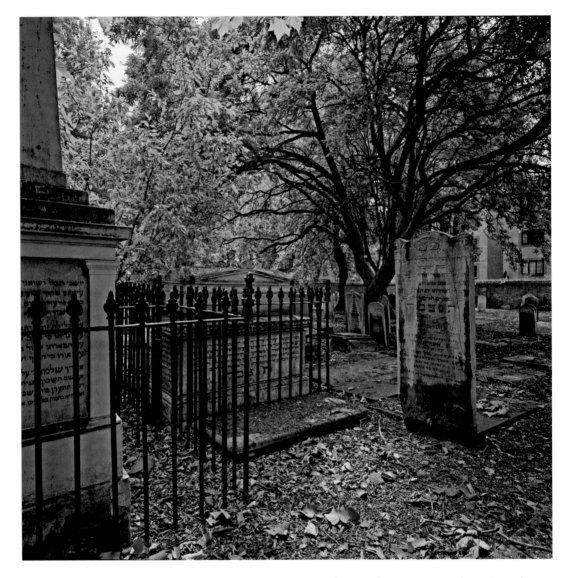

The cemetery is roughly an inverted L-shape and in the northern section there is a cluster of enclosures with large monuments. On the left is the monument of Solomon Hirschel (1762–1842), rabbi of the Great Synagogue between 1802 and 1842 and an important leader in the nineteenth-century Jewish community of the East End. In the centre is a grand enclosure dedicated to Isaac Cohen. It has not been possible to establish who he was or the reason for such a prominent burial place.

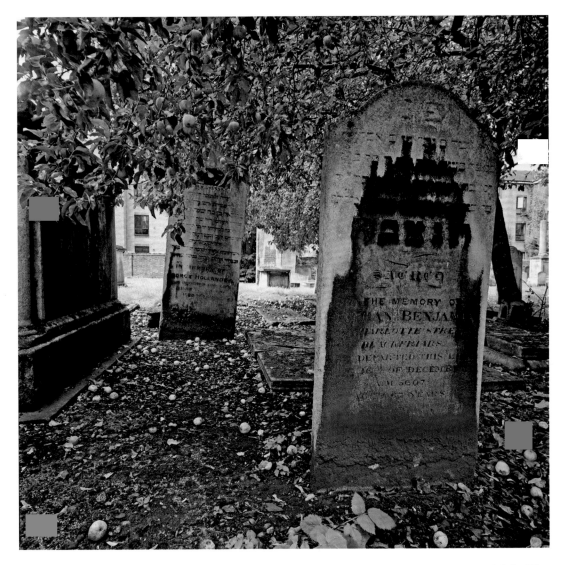

As the month of August leads into September, the fruit of this apple tree ripens and falls. This is the only fruit tree I have seen in the cemetery. The headstone is dated December 1846.

EAST END JEWISH CEMETERIES

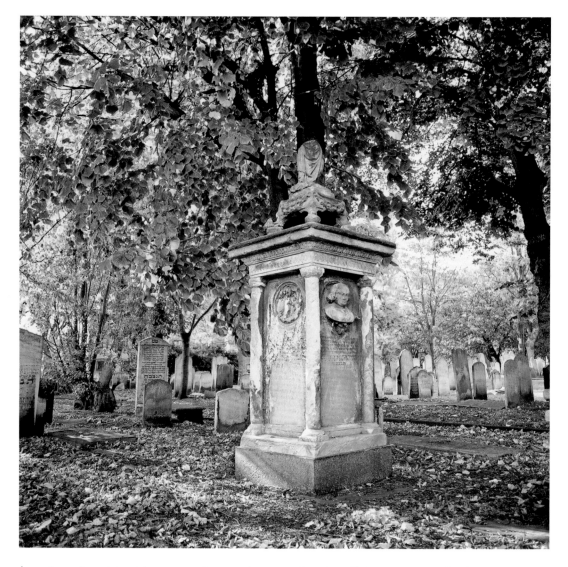

In a prominent position near the southern perimeter of the cemetery is the monument to Miriam Levy. The unusual feature of this memorial is the bust, as well as the scenes from the Bible, which decorate three sides. Miriam Levy died in 1855 and is believed to have been an important figure in the community, revered for her social work in helping the poor and sick. Sadly, nothing is known about why such a lavish memorial exists, or who contributed to its creation.

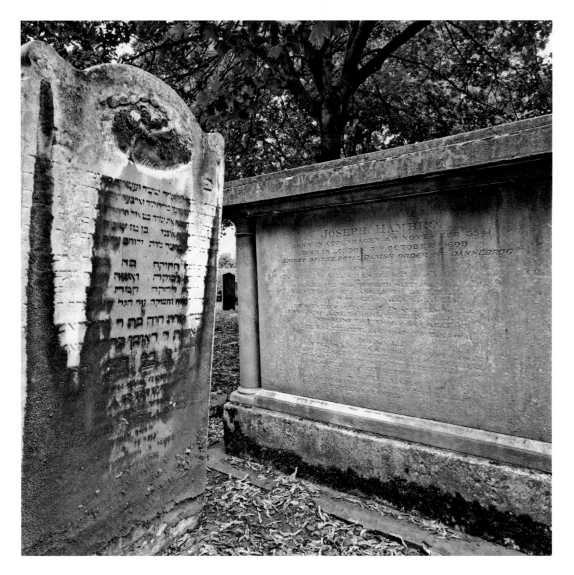

I was drawn to this view by the confluence of the shapes of the memorials and the distant dark monolith for which they create a curtain. It was only when I processed the photograph that I noticed the surname Hambro, associated with the financial institution that for many years was prominent in the City of London. Further research revealed that Joseph Hambro was a successful nineteenth-century Danish merchant banker and was rewarded by being made a Knight of the Royal Danish Order of Dannebrog – a high honour – for arranging loans for the Danish government. His son, Carl Joachim Hambro, settled in London and started the UK banking arm, which existed until near the end of the millennium when it was bought out and subsumed into other banking operations in the City. The name still appears in various combinations in financial institutions to this day.

CEMETERY SYMBOLISM

This is one of the most distinctive tombs in Brady Street and a fine example of cemetery symbolism. On top of the monument is a common nineteenth-century neoclassical symbol in fashion at the time. The draped urn was popular on Victorian (Greek revival) tombstones. The veil could be symbolic of the division between life and death. Since very few cremations were done in the nineteenth century, it most likely does not represent a cremation urn but rather a stylized Greek symbol of the separation of the soul from the body.

However, this is somewhat incongruous with Orthodox Judaism, which requires a body to be buried in the earth – i.e. not cremated but buried.

The large central panel is a fine representation of a common symbol signifying that the deceased is a Levite, one of the Twelve Tribes of Israel, which included the Cohanim. The Levites, as religious leaders, ministered to the Cohanim (Hebrew for priests) during the Temple service. It was the Levites' responsibility to wash the hands of the cohen during the blessing of the congregation. Another interpretation is that the symbol may also represent the water of life.

Framing the central panel are two upturned torches, symbolising the extinguishing of the flame of life.

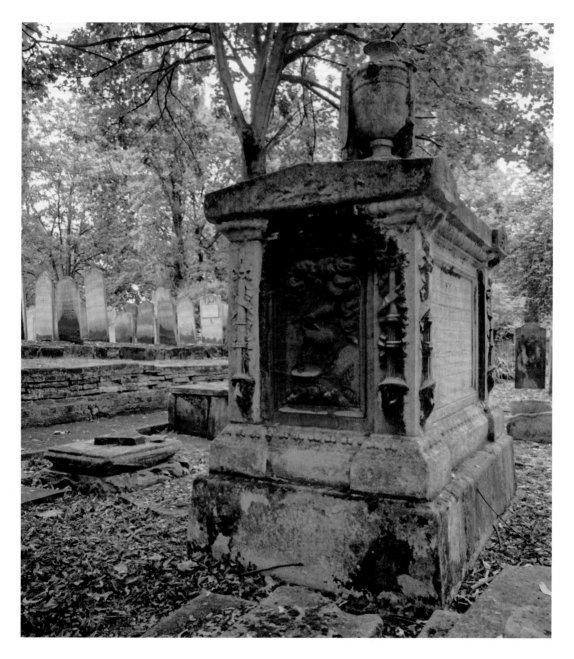

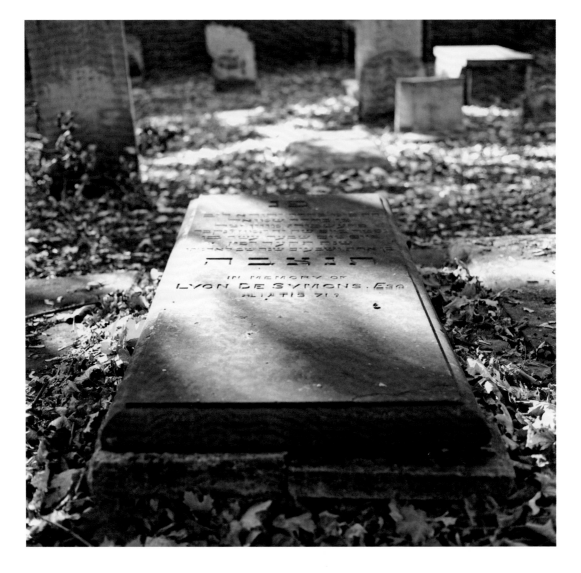

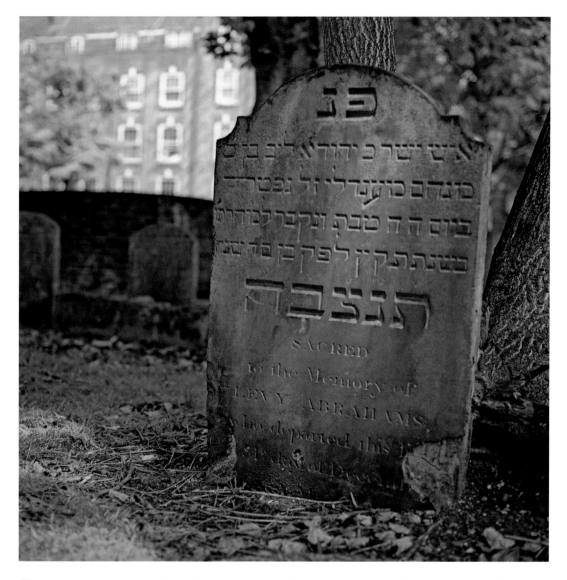

There are many examples of gravestones in the cemetery that have turned a distinctive green colour as they have aged. Gravestone weathering has been the subject of scientific investigation in recent years. There is evidence that discolouration is partly due to the rise in acid levels in rain, especially during the increase in factories and workshops in the area. Another factor is the impact of freeze-thaw action on the soft sandstone material of some headstones, which leads to the flaking of the surface. This allows organisms in the air to invade the exposed crevices on the surface and leads to discolouration.

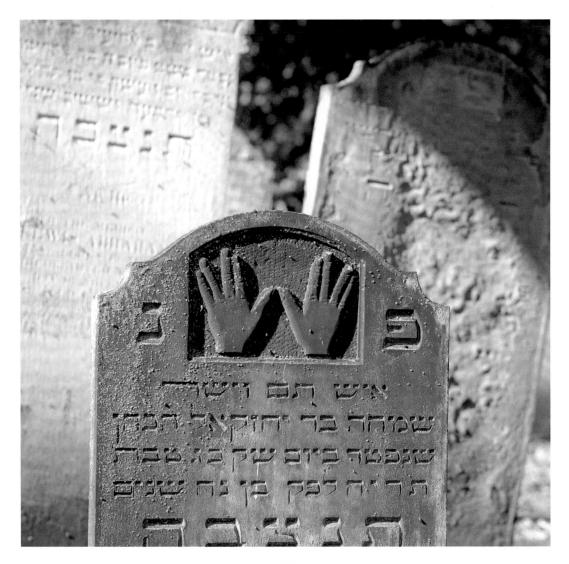

This headstone bears the symbol of a cohen (Hebrew for priest) – the distinctive formation of the hands that is said to signify the Hebrew letter Shin. This is the first letter of several important words including Shechinah and Shaddai (both alternatives names of God). The deceased was a Cohen, a member of the tribe of Levi.

This symbol was used by the actor Leonard Nimoy in his role as the alien 'Spock' in the TV series 'Star Trek'. Nimoy, the son of orthodox Jewish immigrants, recalled the sign being used in religious services and decided to use it as the Vulcan salute for 'Live long and prosper'.

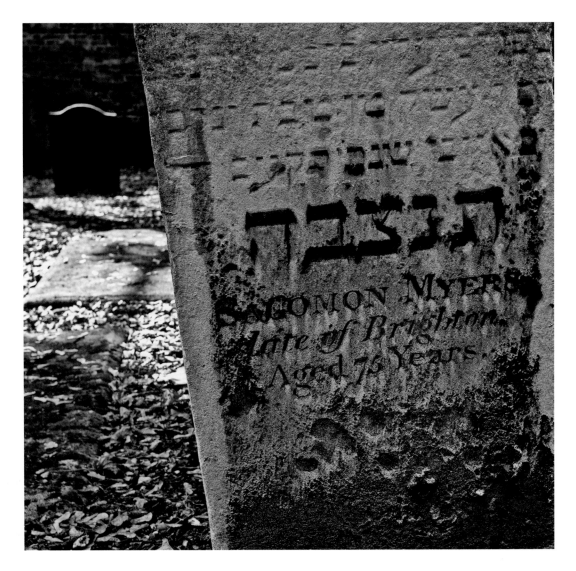

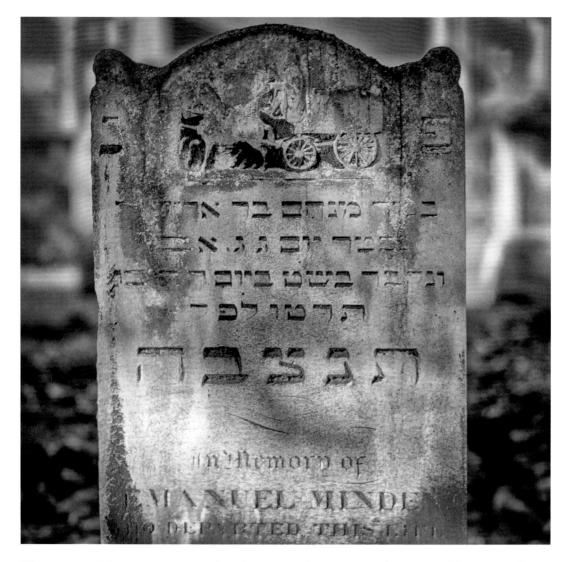

This is one of the most intriguing headstones in the cemetery because of the unique horse and wagon motif. There is no clear explanation of what this may represent, although one view is that it may have referred to the occupation of the deceased.

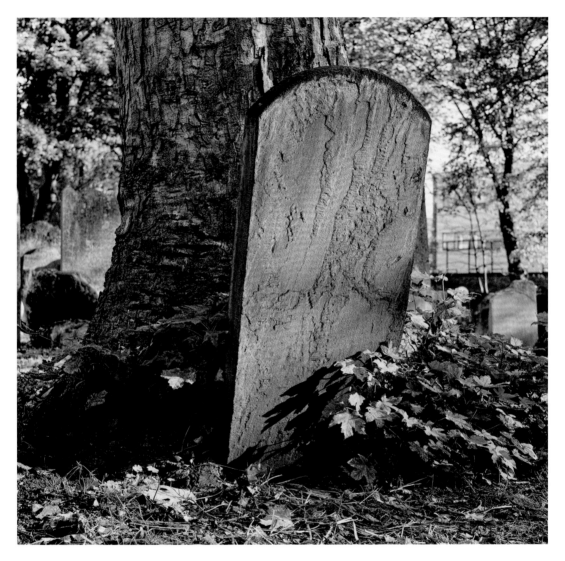

A dramatic example of how a single seed has grown into a massive trunk, which is displacing the headstone.

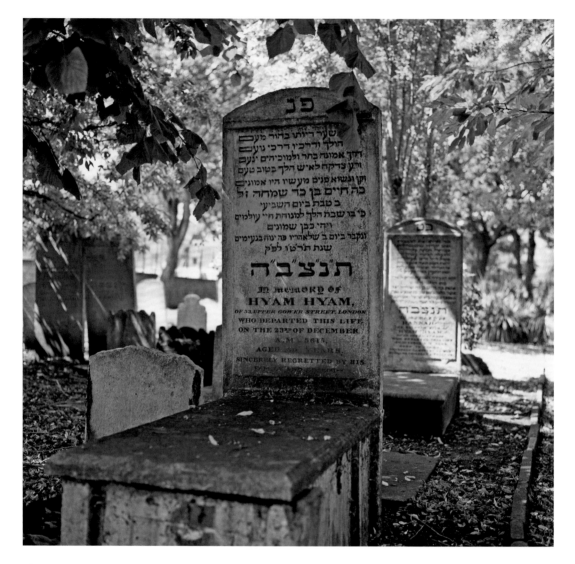

This is an interesting headstone for two reasons. Firstly, it proudly displays the former address of Hyam Hyam, which is Upper Gower Street, Bloomsbury – today the academic heart of London. Secondly, behind his tomb and headstone are those of his wife, Hannah.

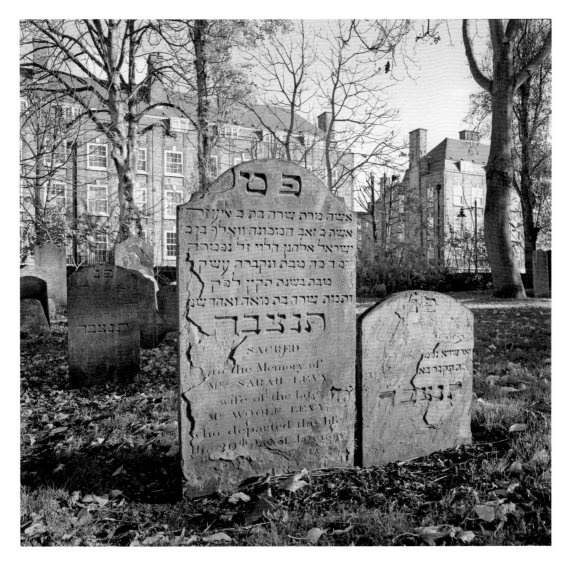

This pair of headstones serves as a further reminder that nature is reclaiming the cemetery. In the winter of 2014, a tree collapsed and crushed these headstones into powder. This photograph is the only permanent reminder that they ever existed and shows the location of the graves they marked.

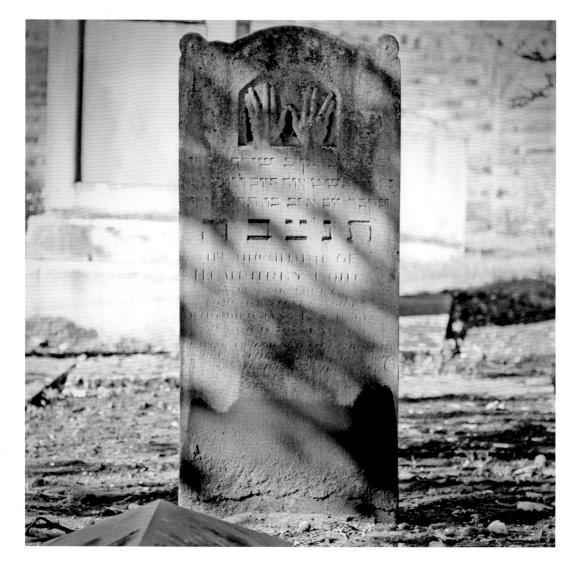

These four headstones are representative of the symbolism that appears throughout Brady Street.

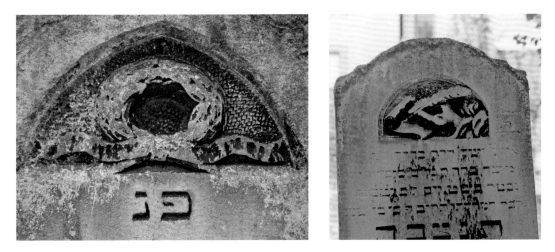

Above left: The tombstone of a man has weathered to the point that it is hard to make out what appears to be a wreath.

Above right: More easily recognisable is this hand holding a quill, which may represent a scholar or possibly even a rabbi.

Below left: The appearance of angels is also a common embellishment.

Below right: The most dramatic symbolism is the tree being cut in half. This is said to represent a person who died at a young age – in effect, being cut down in the prime of life.

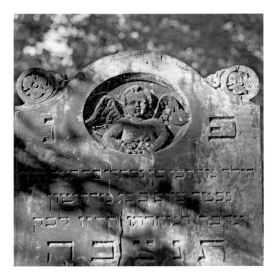

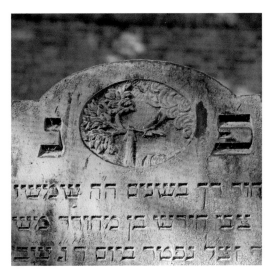

AUTUMN

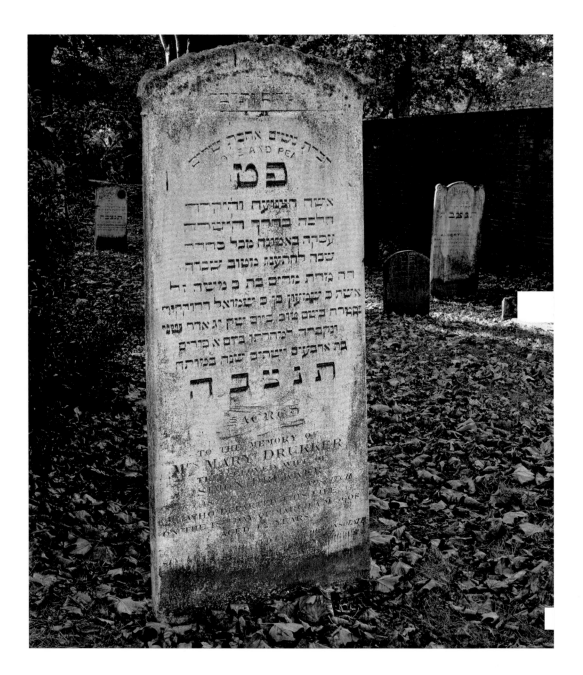

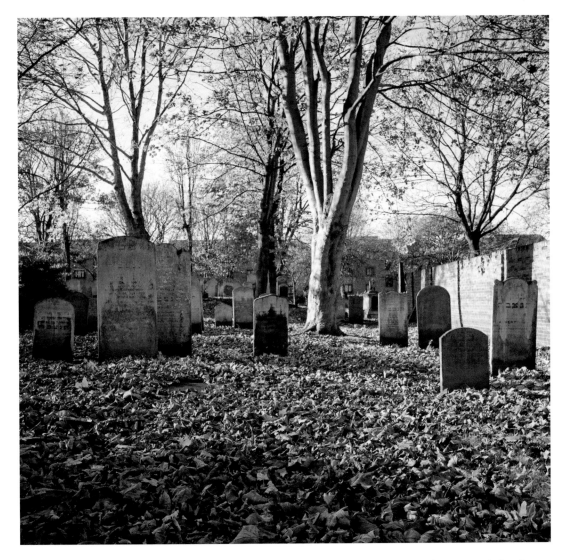

The shadows lengthen and the light increases in contrast as the sun sinks lower in the autumn sky. The trees shed leaves and create a new carpet of muted tones on the cemetery floor.

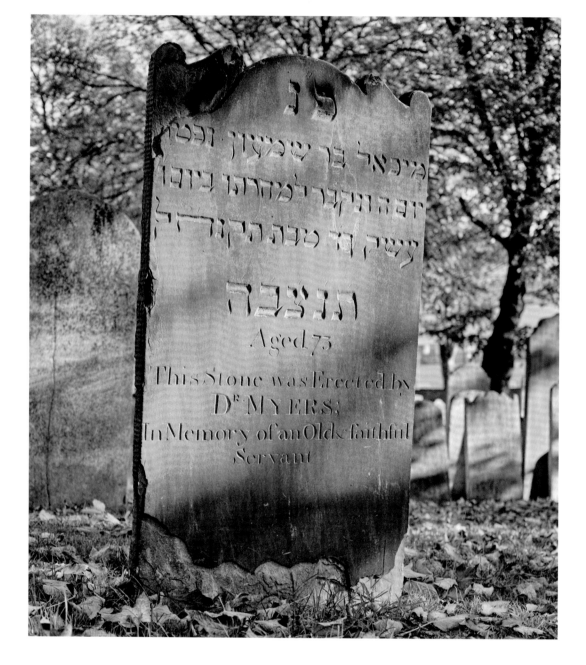

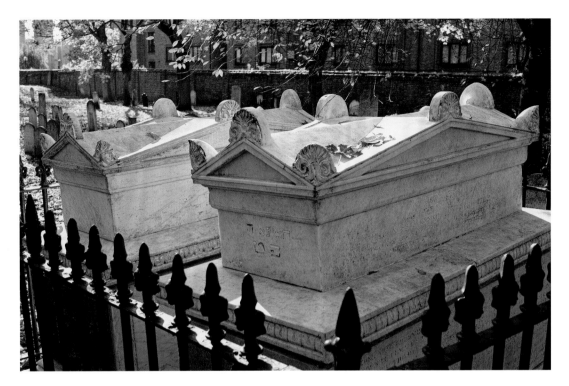

A view of the tombs containing the remains of Nathan Mayer Rothschild (1777–1836) and his widow, Hannah (1783–1850).

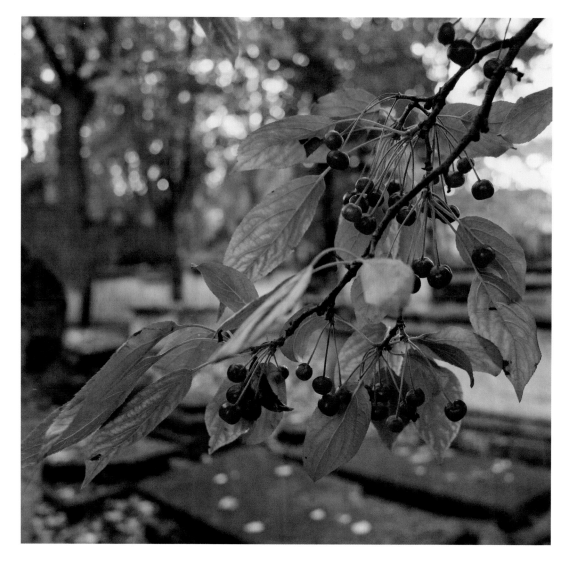

The carpet of leaves thickens and berries begin to form on some of the trees as autumn progresses.

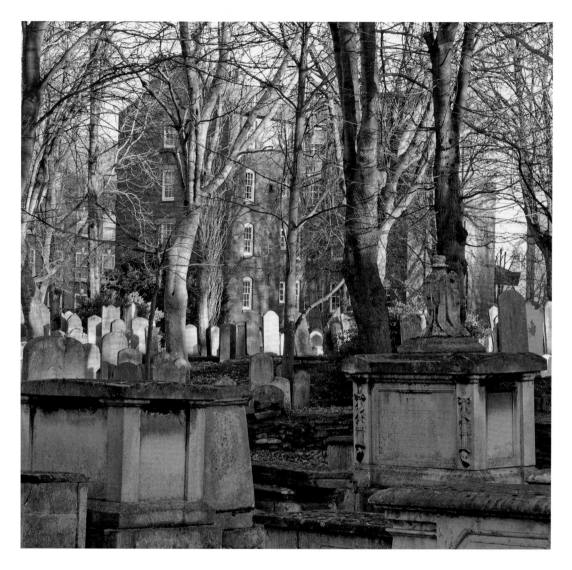

EAST END JEWISH CEMETERIES

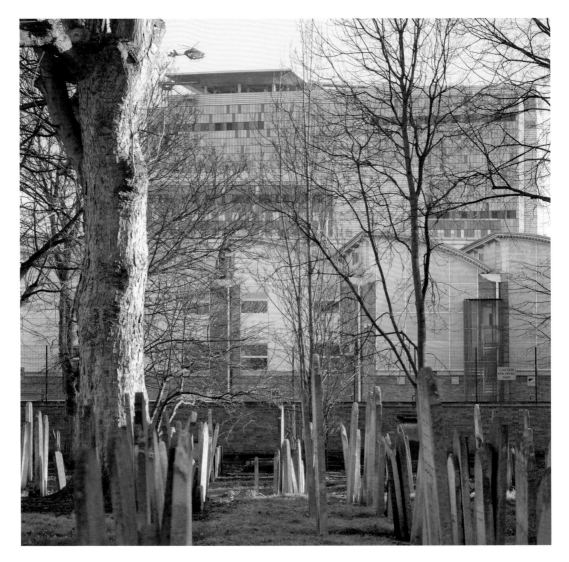

Finally, the trees are bare and the buildings and activity surrounding the cemetery are revealed. Nearby is the distinctive red-brick Mocatta House (1905) on Brady Street, a development by the philanthropic 4 per cent Industrial Dwelling Society, and behind Whitechapel Road is the twenty-first-century building of the Royal London Hospital, with the Air Ambulance arriving on its rooftop helipad.

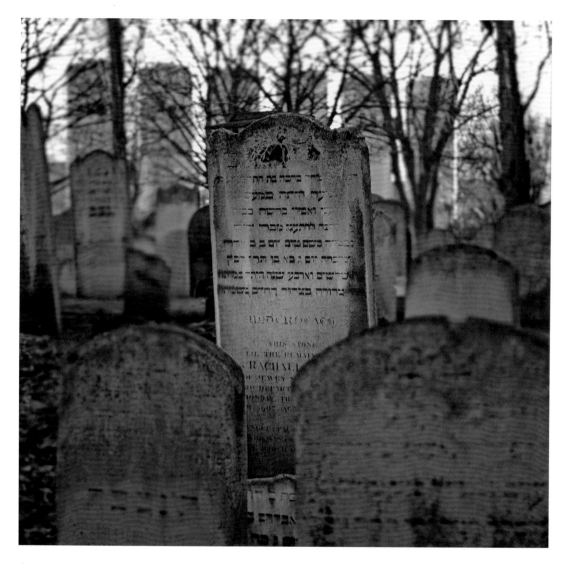

As autumn progressed, the sunsets became fierier. I was fascinated one evening to observe how the low autumn sunlight reflected off the surface of one stone and lit up the stone behind it.

EAST END JEWISH CEMETERIES

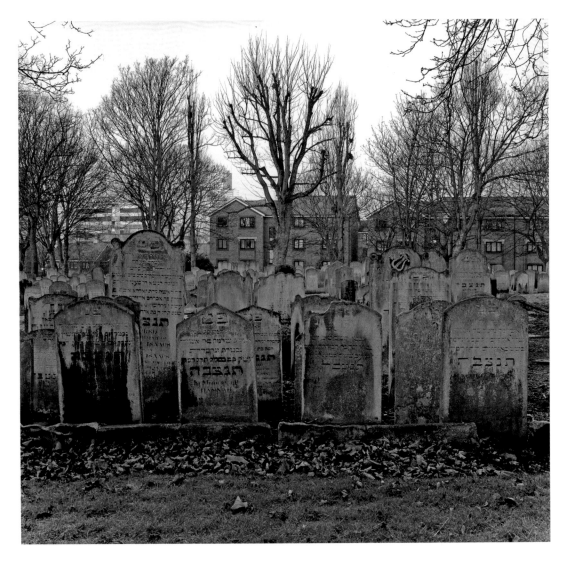

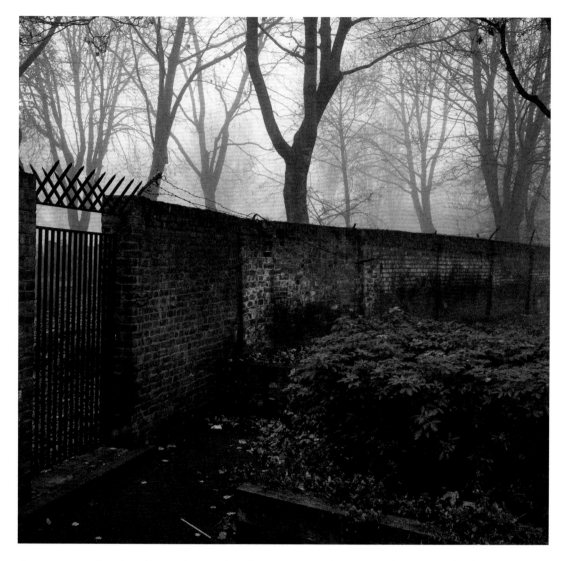

As autumn dissolves into winter, the days start with a mist that shrouds the cemetery, seen here from the entrance in Brady Street.

WINTER

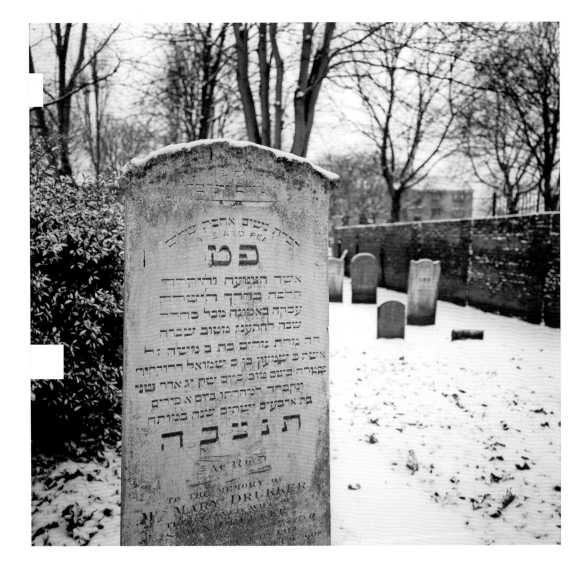

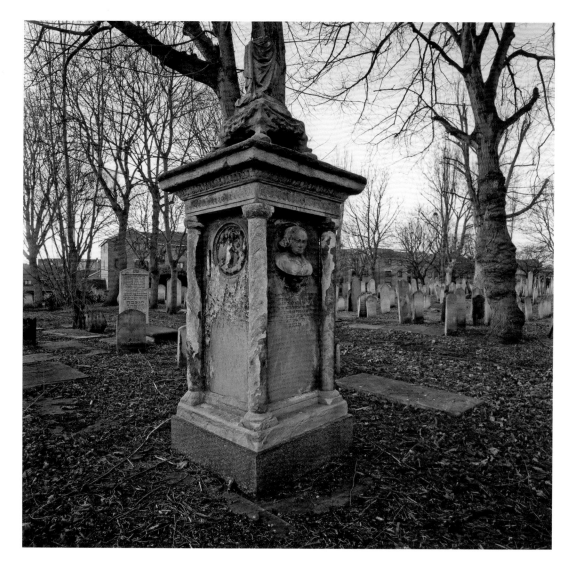

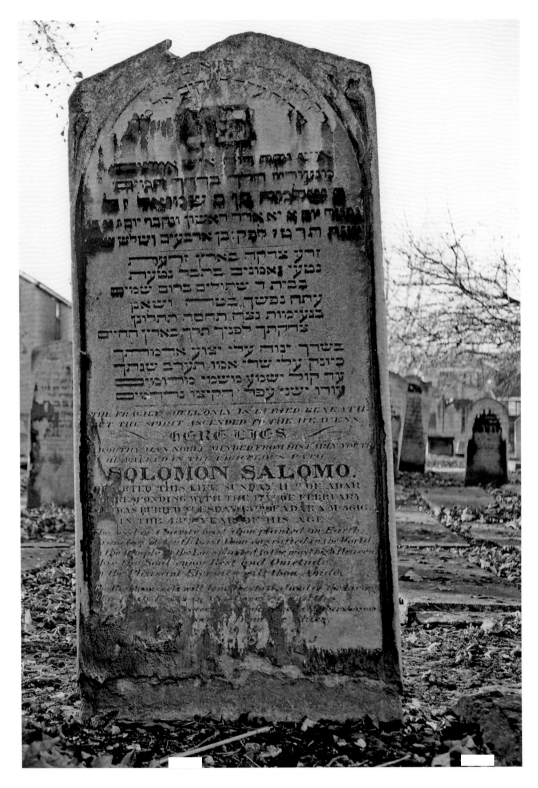

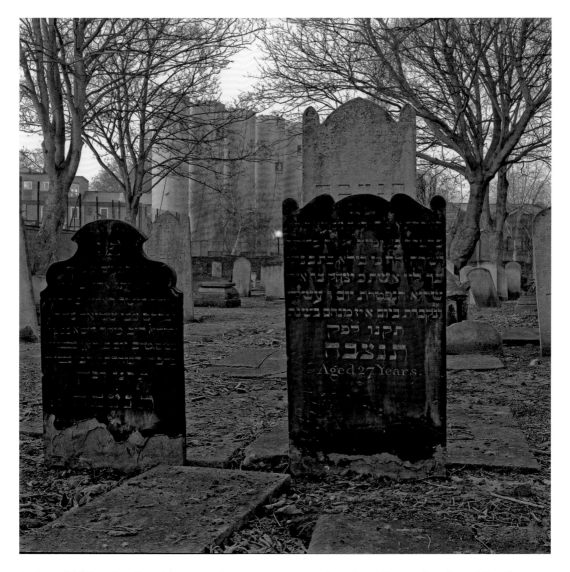

In late 2013 tall yellow 'shotcrete' towers appeared on land being developed for the new Crossrail station in Whitechapel. They provided an unusual backdrop to the cemetery. The south side of the cemetery contains some of the oldest graves. The distinctively shaped top of the headstone is indicative of a Dutch burial – which would have been consistent with the immigration from Holland in the eighteenth century.

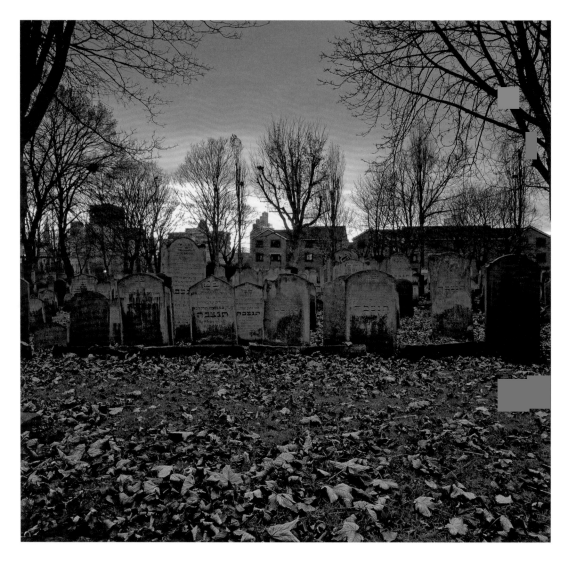

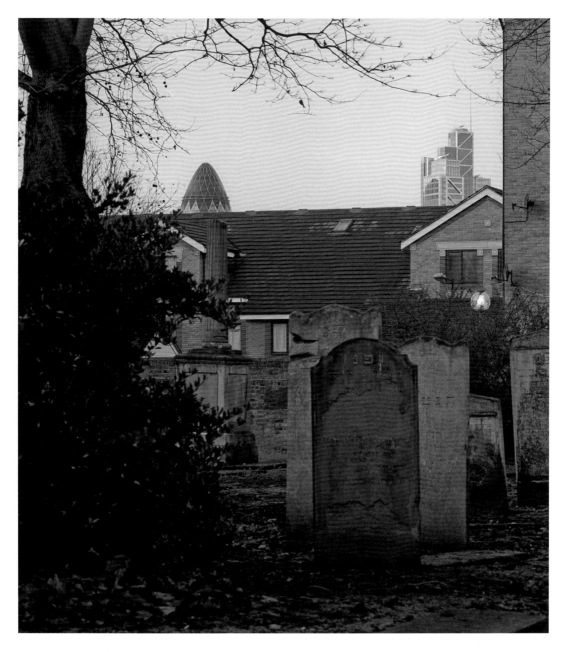

I really enjoyed photographing the dawn in the cemetery on cold, clear winter mornings. Another thing that intrigued me were the glimpses of the buildings in the City, around a mile away as the crow flies, and the contrast they make with the age of the graves in the cemetery.

EAST END JEWISH CEMETERIES

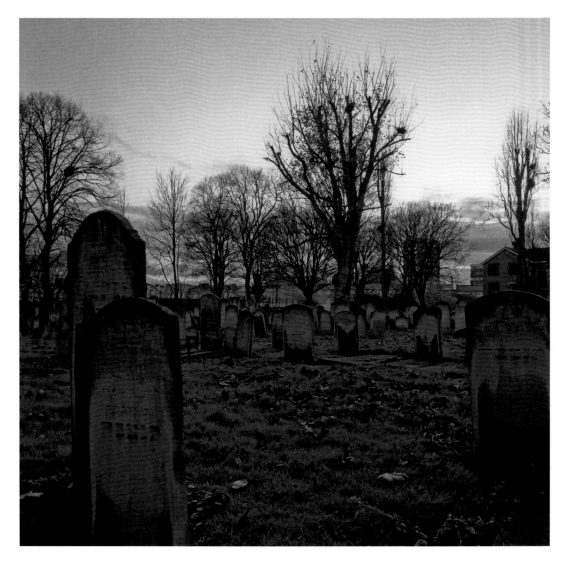

At sunset the backlit trees reveal very clearly the many birds' nests that are occupied during the spring and summer months.

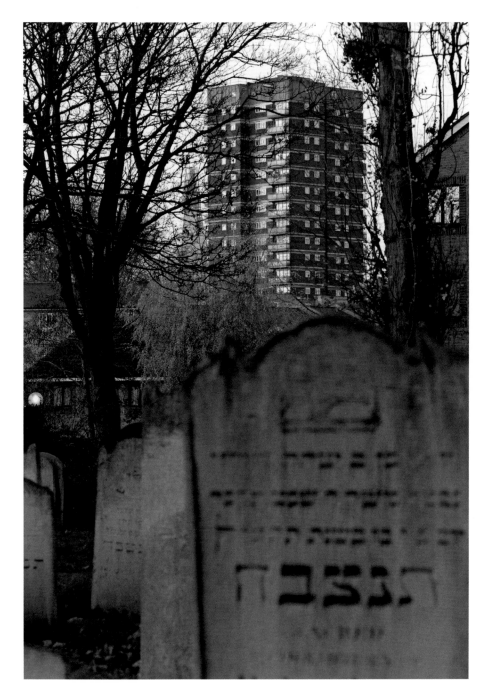

Lining up are a nineteenth-century headstone on the raised area of the cemetery, with the distinctive 1960s tower block of Pauline House in nearby Vallance Road, and the even more distinctive outline of the Shard under construction in Southwark, as it neared completion in the winter of 2011.

EAST END JEWISH CEMETERIES

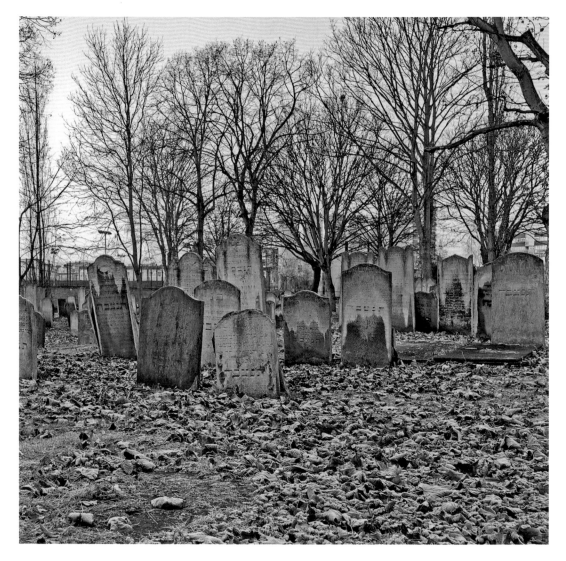

A hard frost carpets the exposed raised area of the cemetery at dawn on a morning in December.

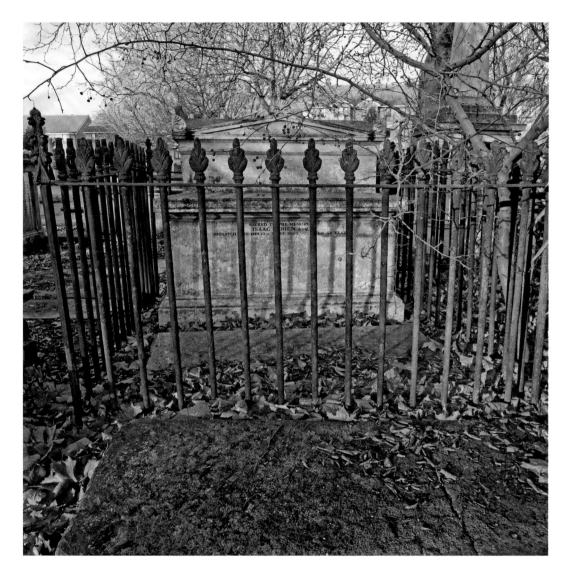

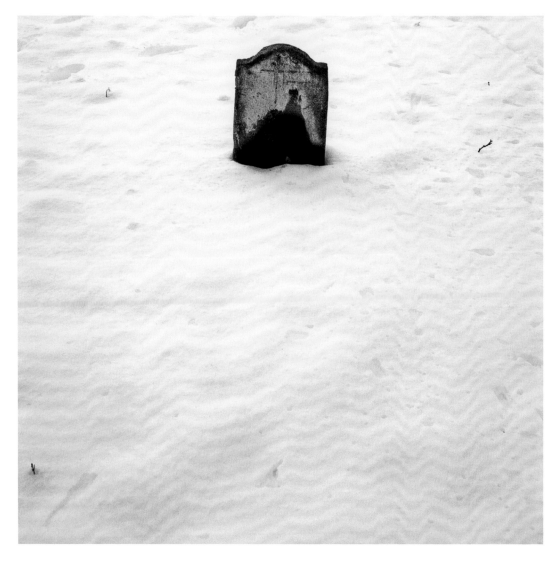

The temperature drops further and in February a significant snowfall carpets the cemetery.

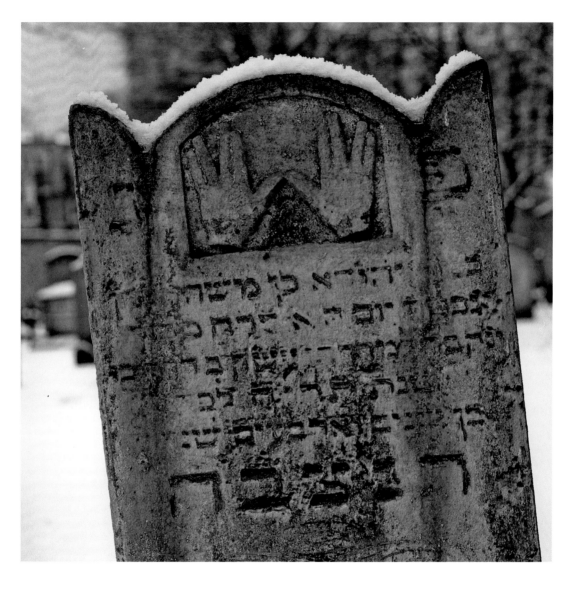

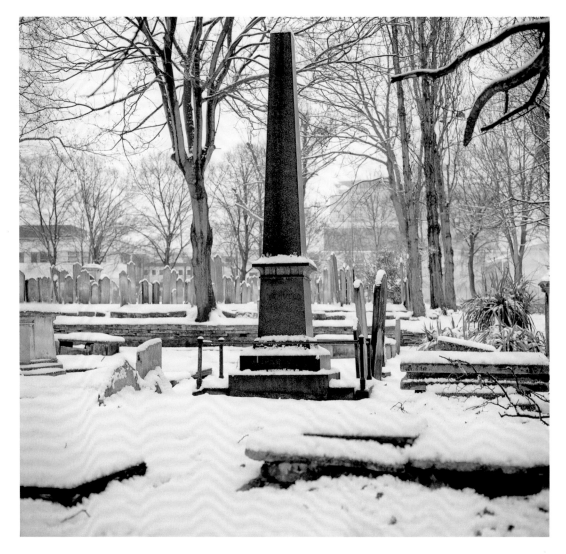

In stark contrast to its surroundings, the prominent pink-granite obelisk to the memory of Hyman Hurwitz (1770–1844) stands out in the winter landscape.

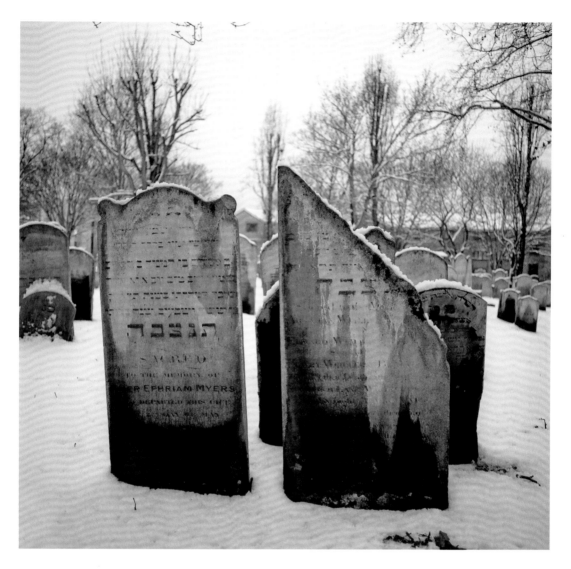

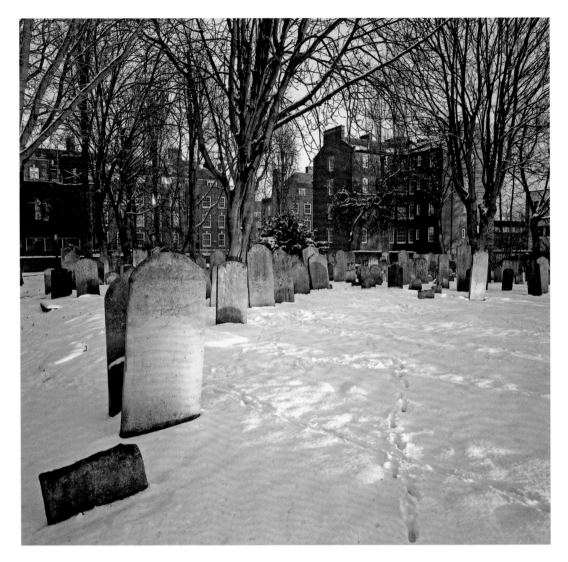

The snowfall is accompanied by golden sunsets in the afternoon. You can see the trails made by some kind of animal in snow in the photograph above – perhaps the cemetery's fox?

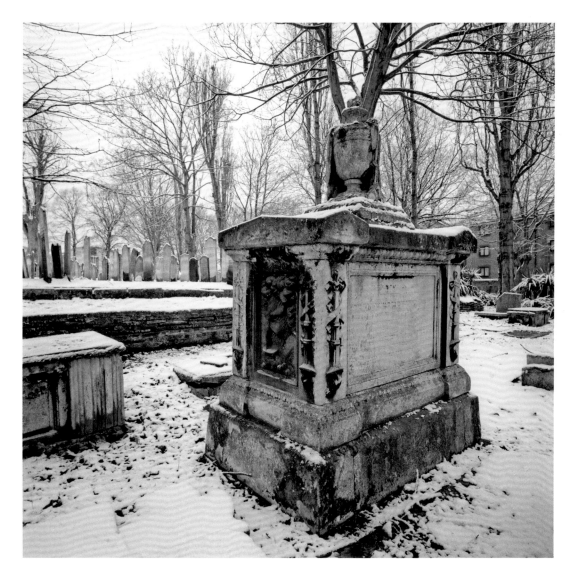

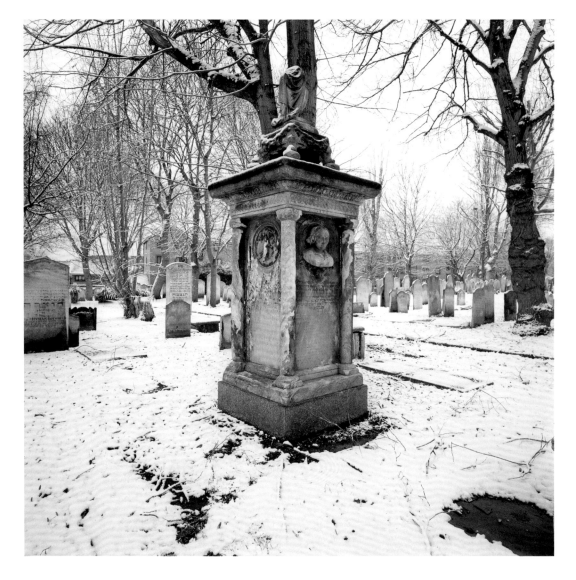

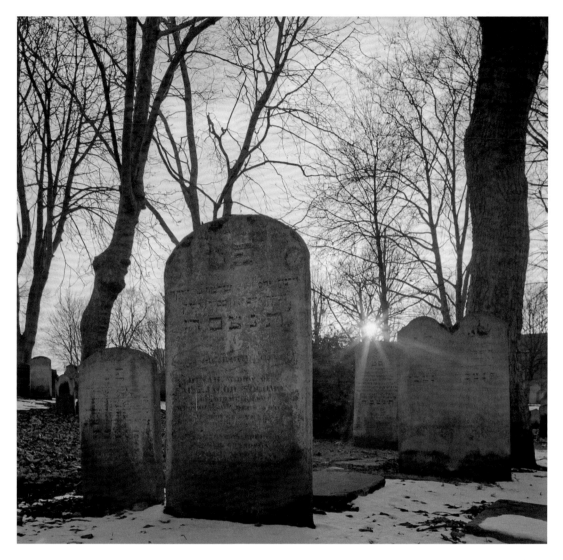

The snow is short-lived and quickly begins to fade.

EAST END JEWISH CEMETERIES

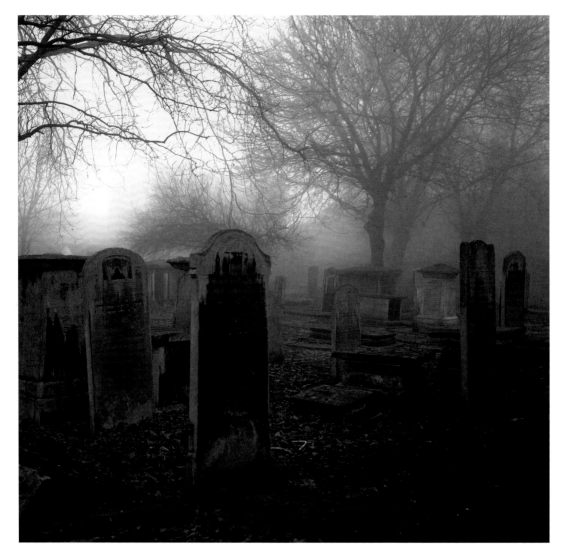

The warmer mornings lead to a thick fog in Whitechapel.

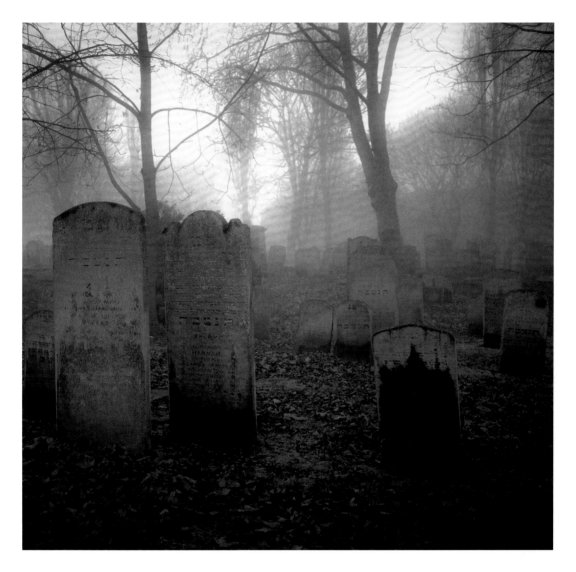

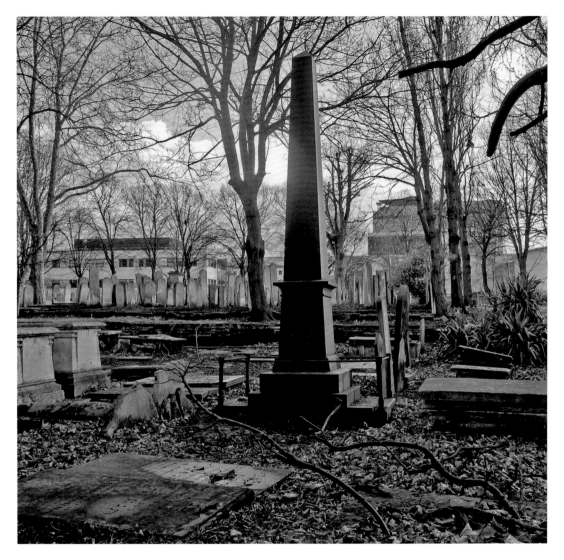

On the cusp of spring, in March.

SPRING

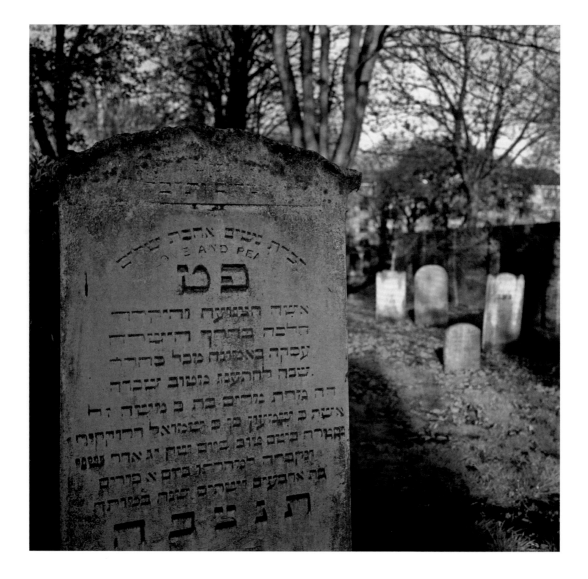

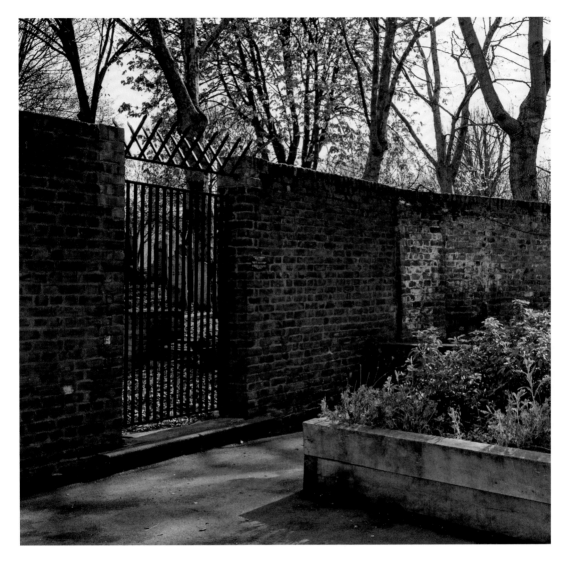

At last, over the cemetery wall I can see that the trees are beginning to leaf.

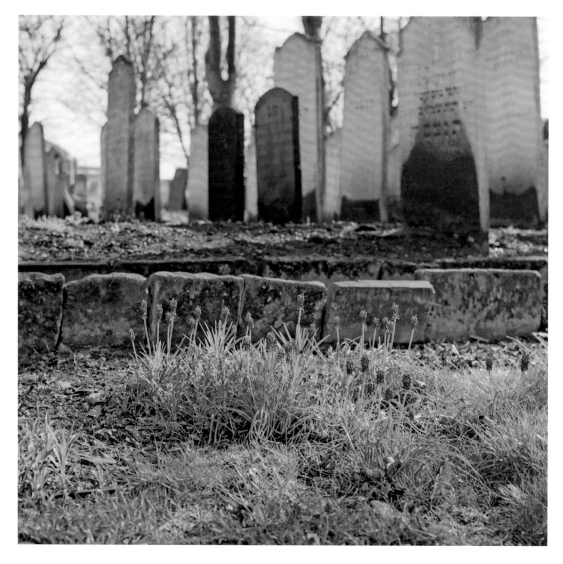

Inside the cemetery, early spring plants begin to appear, such as these purple muscari in late March.

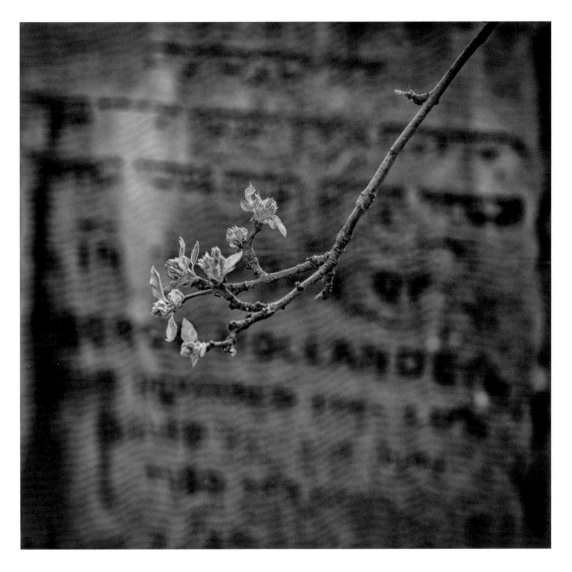

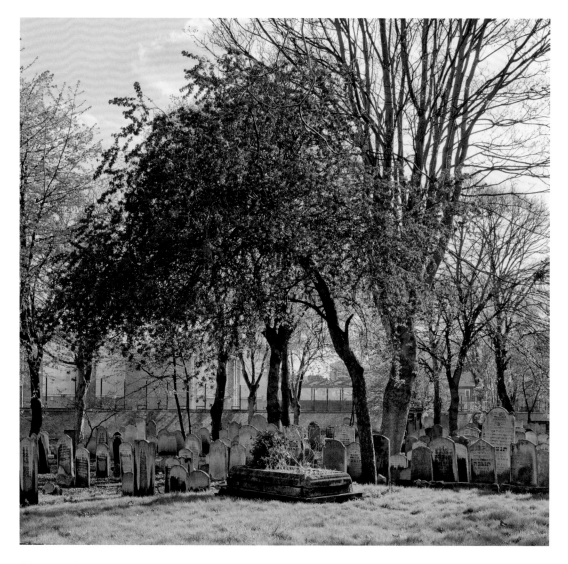

Along with the early spring flowering plants, the trees are also in blossom as they respond to the rising temperature in April and May.

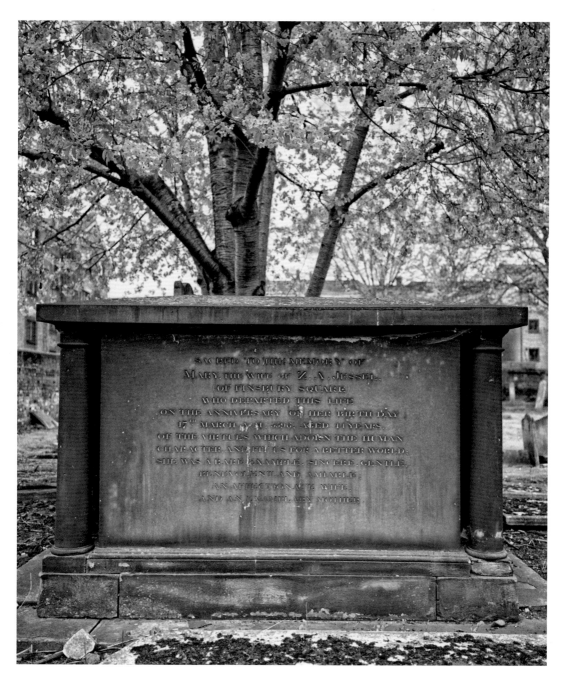

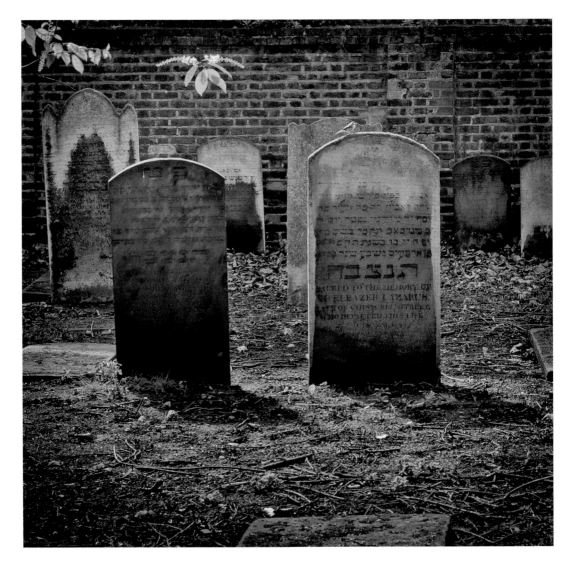

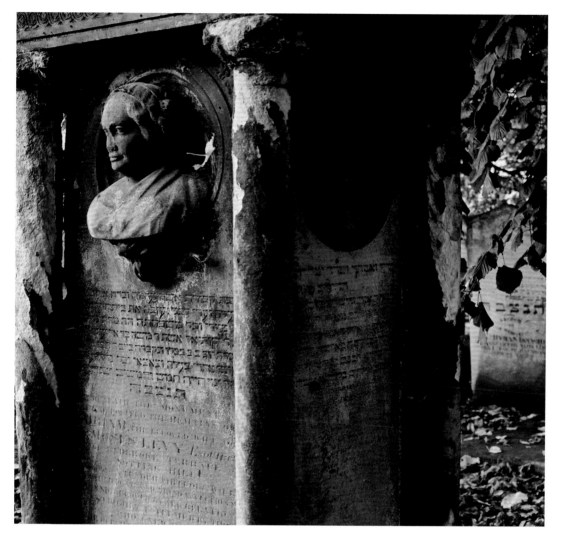

MIRIAM LEVY

The Miriam Levy monument dominates the southern side of the cemetery. She died in 1855, only three years before the cemetery officially closed. Very little has been recorded about who Miriam Levy was and why she deserved such a lavish memorial. The use of a bust of the subject is most unusual in Jewish burial practice, which makes it all the more interesting. There is some belief that she was involved in the opening of an early soup kitchen (a charitable activity which continued in the East End Jewish community until well after the Second World War). The memorial has details of her husband and children, and records that she is late of Ladbroke Terrace, Notting Hill.

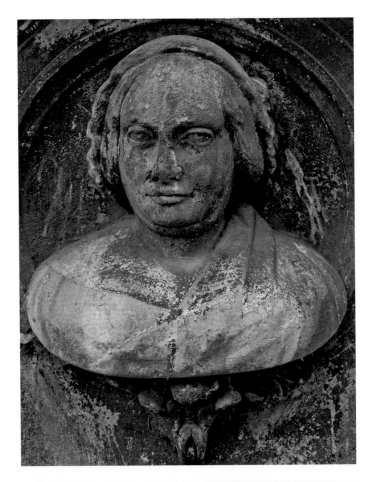

All four sides of the tomb contain bas reliefs. This is a close-up of the bust of Miriam Levy. It is assumed that this is a likeness.

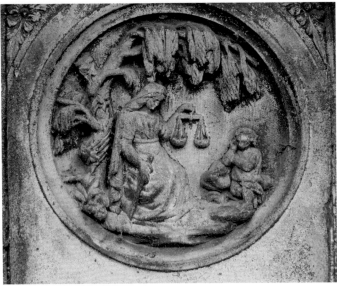

An interpretation of this panel is that the seated woman holding the scales could represent the attribute of justice and the child could represent the Jewish people.

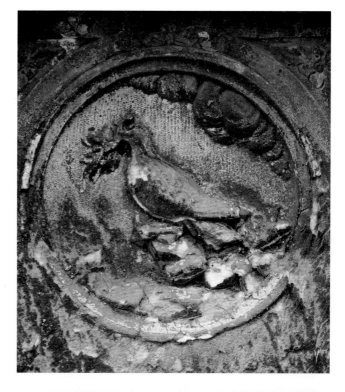

The most easily identifiable of the reliefs is this one that appears to relate to the great flood story in the Old Testament. Noah tests how quickly the flood is receding by releasing a dove. At one point it returns with a branch in its beak, indicating that the waters are receding.

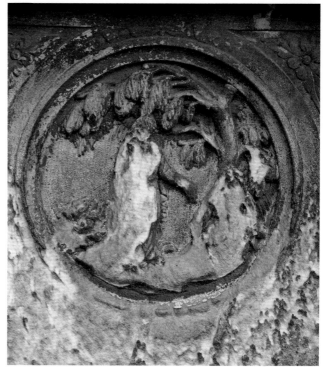

Sadly, this relief has suffered the most weathering, which makes it harder to interpret. If the panel overleaf represented justice, then it might follow that this panel would represent mercy. The standing female figure appears to be beckoning a smaller figure, which can be assumed to be a baby – which, again, would represent the Jewish people.

SUMMER

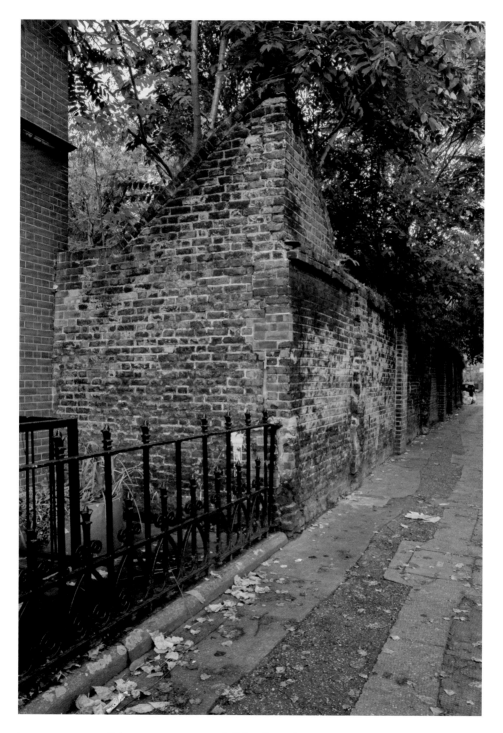

The dense canopy of the trees, now in full leaf, spill out over the eighteenth-century wall of the cemetery on Brady Street in Whitechapel.

EAST END JEWISH CEMETERIES

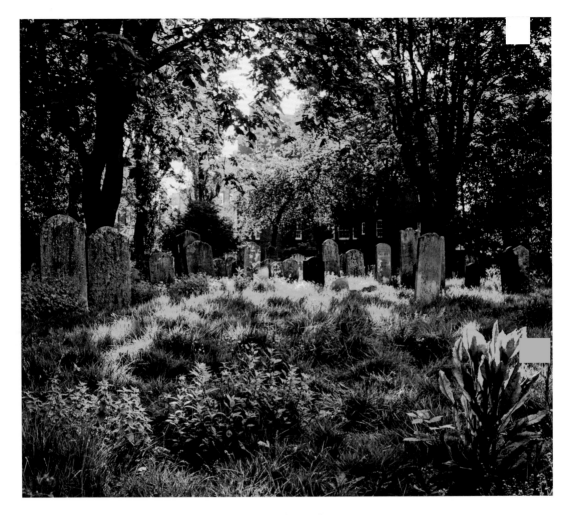

Inside the cemetery, the foliage grows heavily in the warm summer sun.

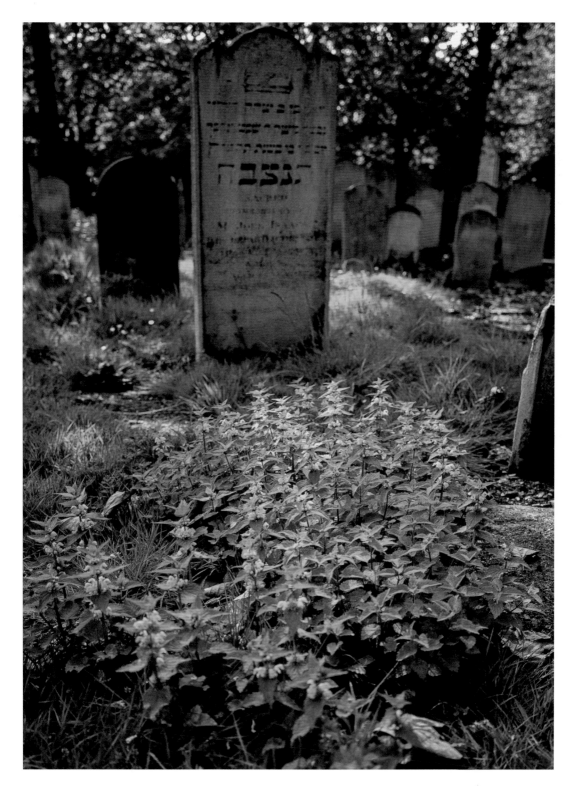

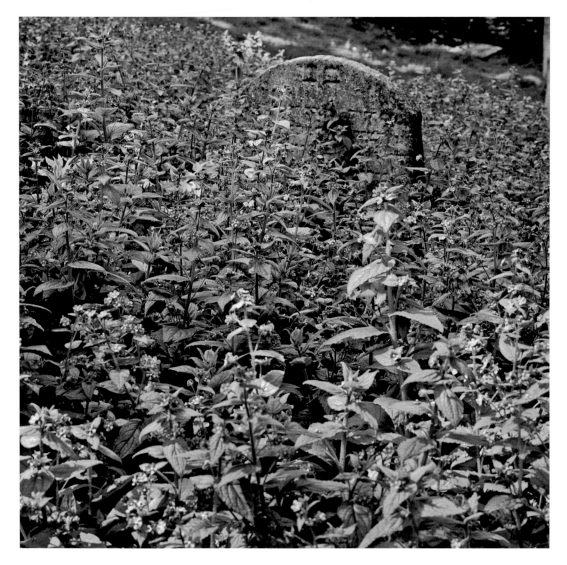

After the starkness of the winter months and hesitant changes in spring, the cemetery now has lush beds of nettles and expanses of blue-flowered green alkanet.

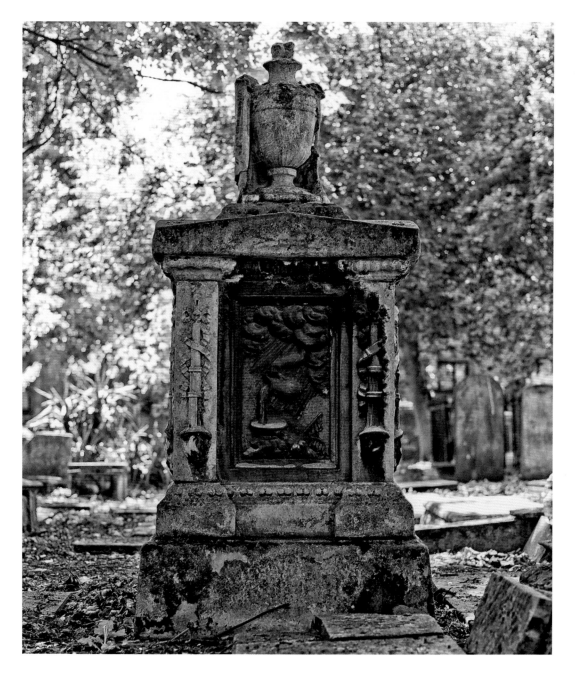

The dense summer foliage serves to hide the built-up surroundings of the cemetery. At this time of year, one can feel quite isolated from the urgent activity of a heavily populated and thriving inner-City area.

A field of purple flowers rises almost to the height of a headstone on the central raised area of the cemetery.

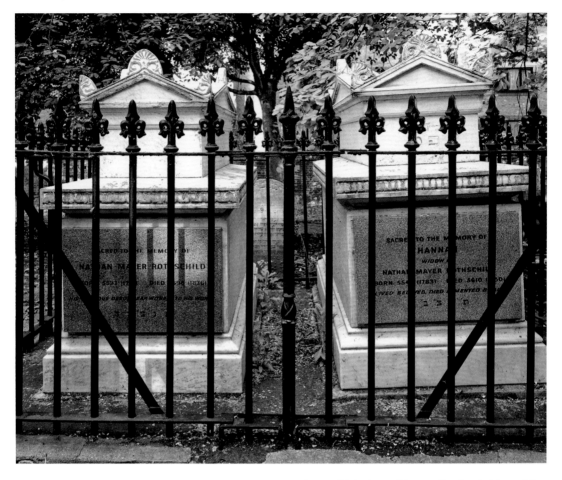

This enclosure contains two important graves: that of Nathan Mayer Rothschild and his wife Hannah (nee Cohen). The two marble sepulchres adapt to the seasons. In winter they are cool and bright but in the summer they take on warmer colours and are often dappled by the shadows from nearby trees falling across them.

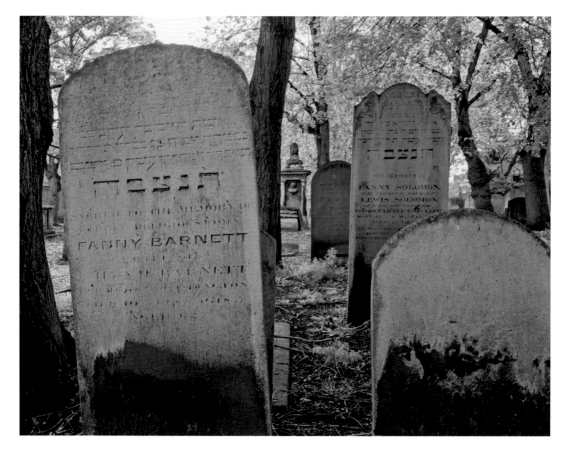

I could not help noticing the coincidence of the popular nineteenth-century female names on these two headstones. Likewise, the pair of headstones bearing the mark of the Cohanim.

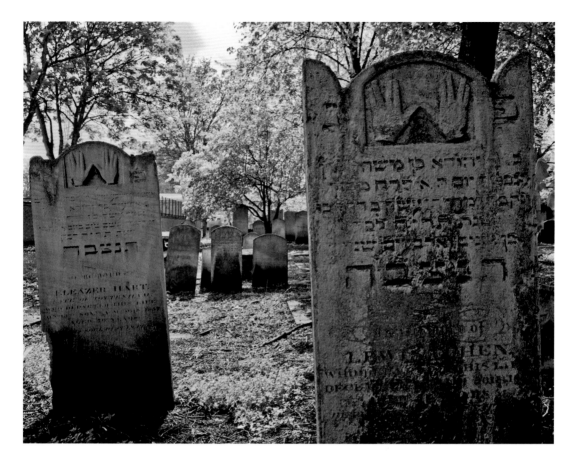

EAST END JEWISH CEMETERIES

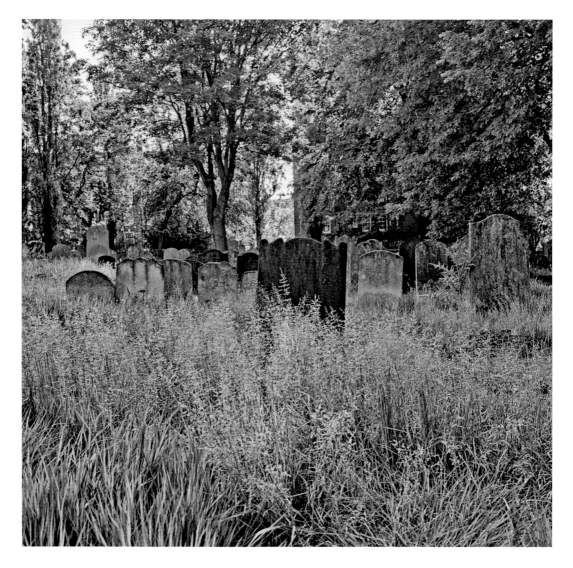

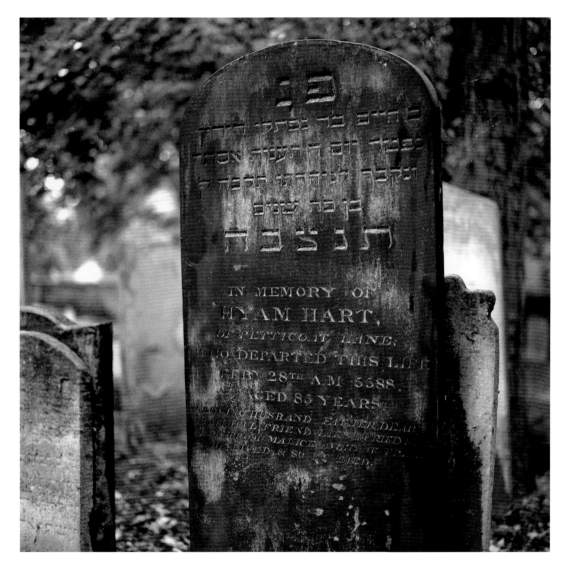

פ.נ

ציון על קבר מרת אלמנת הר''

לפני הזמן ה''ם החיה אשת

ושבי בחורתה יחיד ה''

מ קבר עטרת תפארת

תנצבה

IN MEMORY OF
HYAM HART,
OF PETTICOAT LANE,
WHO DEPARTED THIS LIFE
FEB. 28TH A.M. 5588,
AGED 85 YEARS.
A GOOD HUSBAND FATHER DEAR
A FAITHFUL FRIEND LIES BURIED
FREE FROM MALICE VOID OF
HE LIVED & SO HE DIED.

This headstone dating from the 1820s bears the original name for Middlesex Street, Petticoat Lane, famous for its market, which is still in existence. The name was changed in 1846. A frequent explanation is that it was too immodest for Victorian tastes but actually it was linked to the proximity of the county of Middlesex.

Many of the headstones in the cemetery bear local street names, which are still in existence and provide a powerful link from the past to the present.

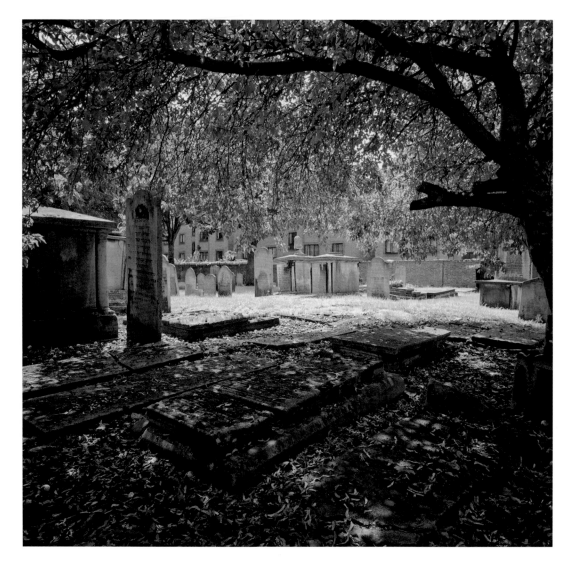

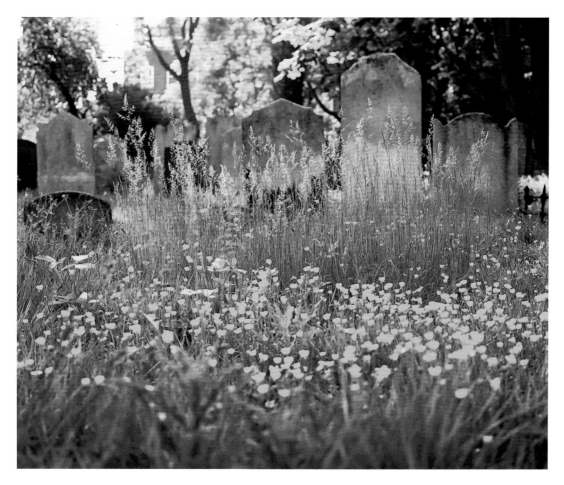

After five years and many visits to Brady Street at all times of day, in all kinds of weather and throughout all four seasons, I felt I had finally accomplished what I set out to do – capture a photographic representation of a unique natural environment in one of the world's most iconic urban areas: Whitechapel.

ALDERNEY ROAD

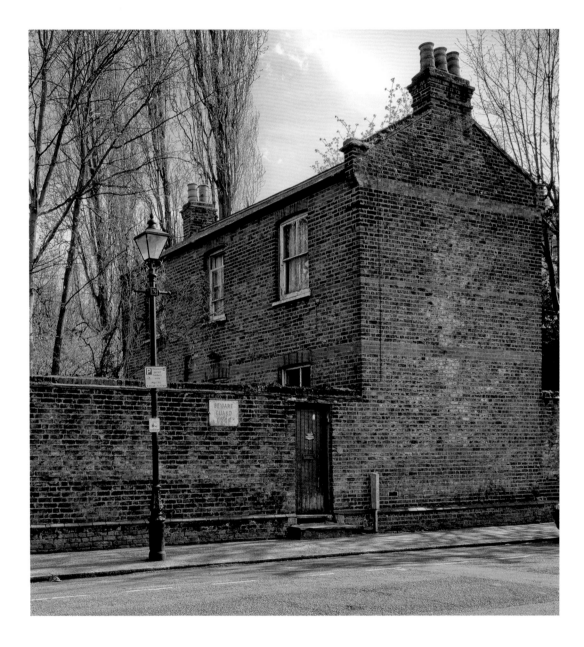

As a result of my work in the Brady Street Cemetery, the United Synagogue asked me to undertake photography in an older cemetery that they own.

Alderney Road is one of the oldest Jewish cemeteries in London – in fact the United Kingdom. It harks back to the seventeenth century and the time shortly after the English Civil War when the Jews of Europe began to filter back into England, having been expelled by Edward I in 1290. It is a matter of debate as to whether Oliver Cromwell was responsible for the readmission of Jews to England, or whether it was a pragmatic decision by the wider community to encourage settlement by Jews who could then stimulate international trade and commerce with the Jewish communities in Amsterdam and elsewhere in Europe. Whatever the reason, a relaxation in attitudes to immigrant communities led to the return of the Jews, who brought skills and labour to the East End of London.

The cemetery was established in 1696 by the gift of Benjamin Levy. Due to its age, many of the graves have been lost to time – although there remain a small number of significant burial sites that are still visible. Unlike Brady Street, the cemetery has not gone back to nature to any real extent. It is a much smaller plot of land and for that reason has probably been easier to maintain over the years.

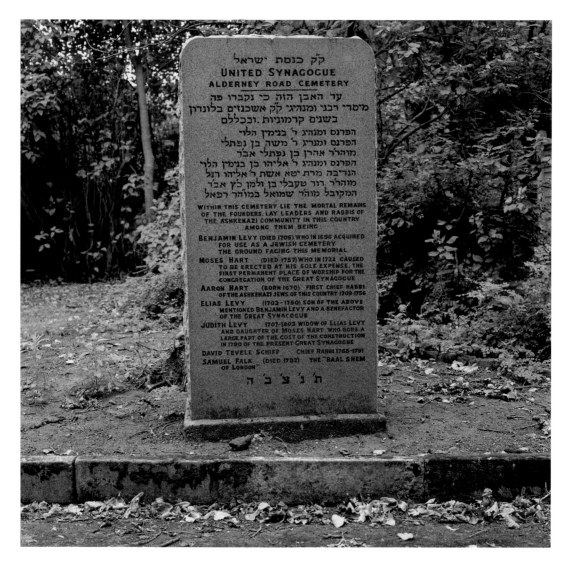

The magnificent memorial stone near the entrance to the cemetery gives a short history of the site and the many important graves it contains.

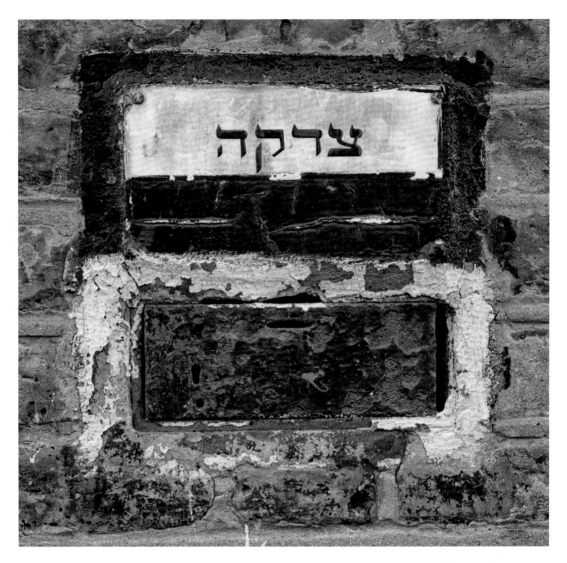

The Hebrew inscription is 'Tzedakah', which signifies the act of giving to charity. Collections of Tzedakah are an important aspect of Jewish religious observance, which teaches the obligation to support and help others less fortunate.

EAST END JEWISH CEMETERIES

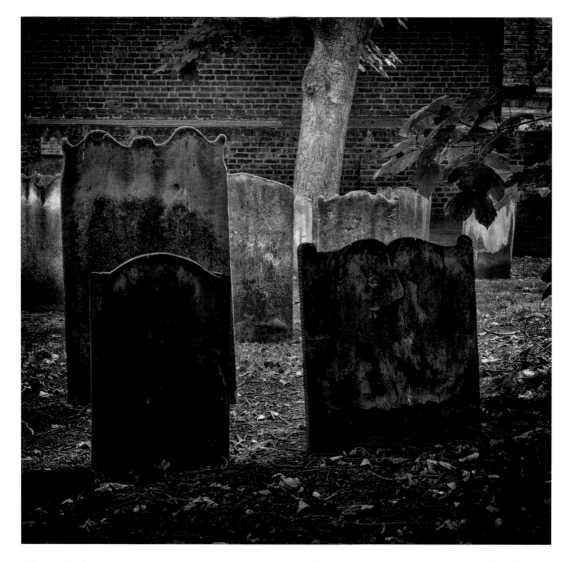

Most of the headstones in the cemetery date from the earliest time that the Jewish community returned to the United Kingdom. The effect of weathering, in some cases for over 300 years, has rendered the surfaces smooth and bare. The ornate scrolled top of these headstones is typical of a Dutch style of memorial of the seventeenth century.

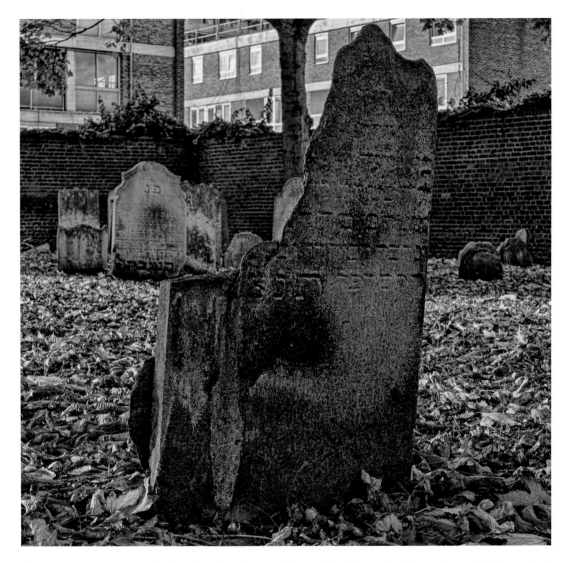

My attention was caught by this headstone due to the dramatic fracturing, which reminds me of a relic from a prehistoric stone circle. It makes an interesting contrast to see this stone, from the eighteenth century, in juxtaposition to unremarkable 1970s architecture in the background.

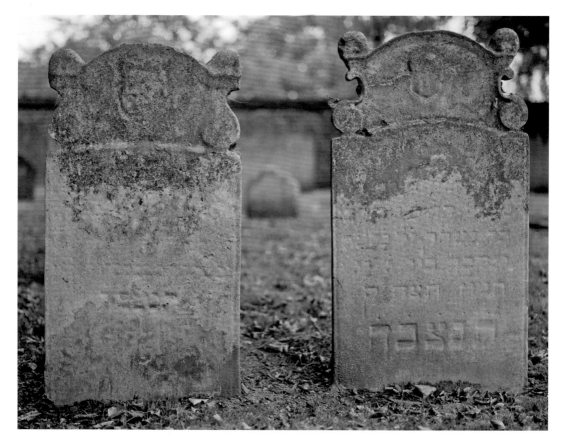

These attractively shaped headstones are clearly heavily influenced by a Continental style – indicative of the first-generation nature of the Jewish community in the late seventeenth century.

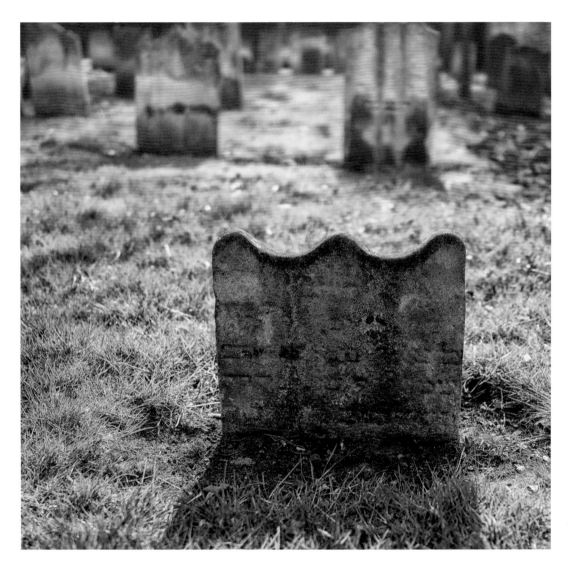

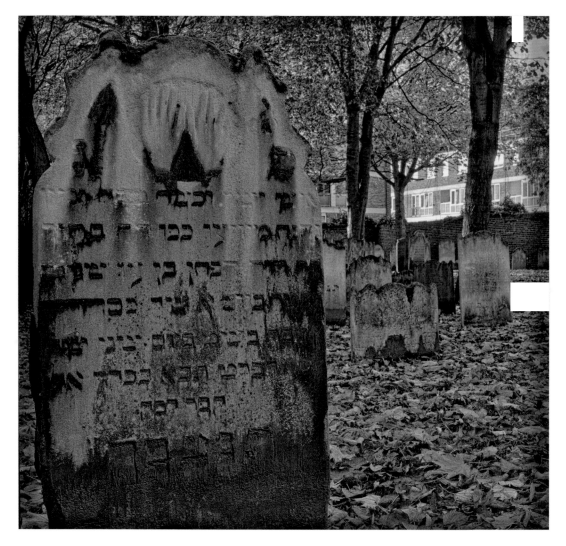

The familiar motif of the hands, signifying a Cohanim, is inscribed on this very old headstone.

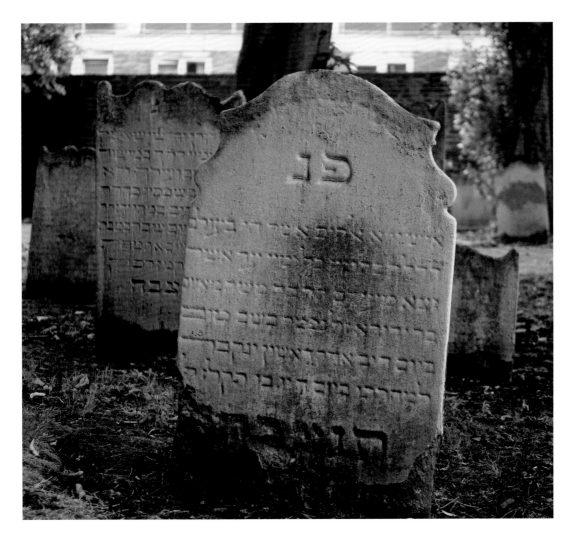

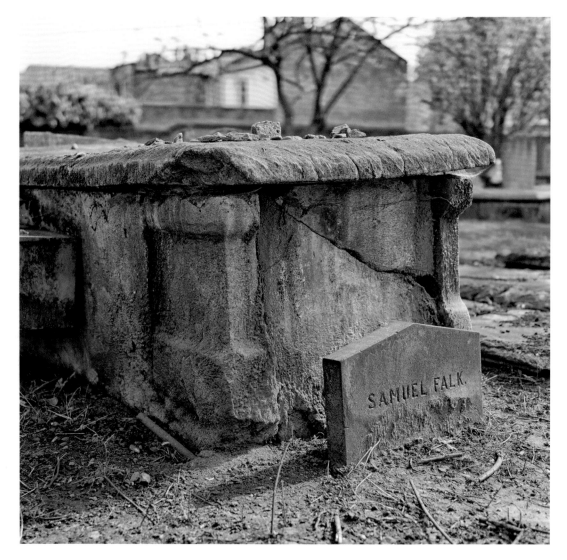

The grave of Samuel Falk, the 'Baal Shem ("Master of the Name") of London'. Falk was a prominent and controversial figure in the eighteenth-century Jewish community of London as he was the leading exponent of Kabbalah, a mystical interpretation of Jewish traditions. There is some evidence that in his native Westphalia he narrowly escaped being burnt at the stake as a suspected sorcerer. On moving to London later in his life, he enjoyed great success as a mystic and amassed wealth from providing his services, much of which he left to charitable causes after his death. The stones left on the top of his memorial, a traditional practise by visitors to a grave, are a testament to his continuing prominence among the Jewish community.

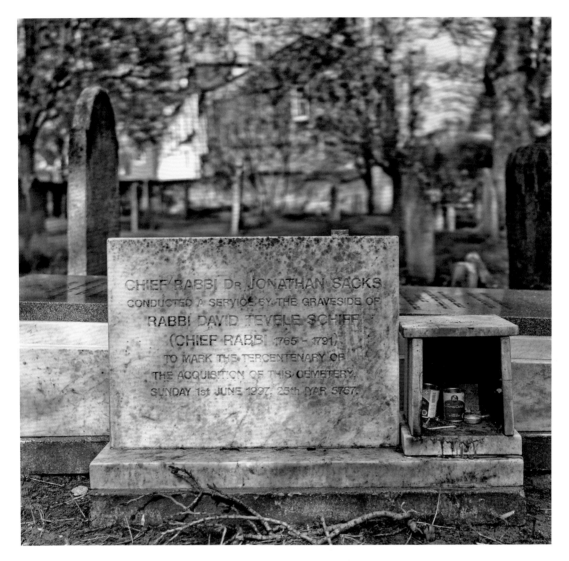

At the graveside of the prominent chief rabbi of the Ashkenazi Jewish Community, David Tevele Schiff (1765–1791), the memorial stone commemorating the tercentenary of the founding of Alderney Road bears the name of the then chief rabbi, Dr Jonathan Sacks, now Lord Aldgate.

ACKNOWLEDGEMENTS

The author would like to thank the following people for their help and assistance in creating this work:

Top of my list has to be Melvyn Hartog of the United Synagogue, who had the foresight to understand my unusual request, for authorising the project and this book and for providing me with access to Brady Street and Alderney Road cemeteries.

Leonard Shear, also of the United Synagogue, gave me his own insight into the cemetery and provided me with information on how to interpret the headstones, as well as pointing out some of the interesting ones to get my project started.

I was very fortunate to be introduced to Rachel Kolsky (with whom I have now authored two other books), not only for her fine introduction to the book but also her continual encouragement during this project and for providing her knowledge during the review stage of the initial manuscript.

My sister, Miriam Halahmy – who is a busy author in her own right – took the time to read my draft manuscript, then edited my words into something far better than I could achieve alone.

I was also aided by Rabbi Dr Charles Middleburgh, who helped to interpret the Miriam Levy monument.

Ronnie Cohen for his general advice on headstone symbolism, Jewish traditions and terminology.

My wife, Julie, as usual, also did a final proofread to ensure I had not made any bad errors in my writing (and typing). She has also managed to put up with my moods and frustrations, which are never far from creative activity – especially when they arise out of one's own limitations.

Finally, all the support from Amberley for bringing this book to fruition.

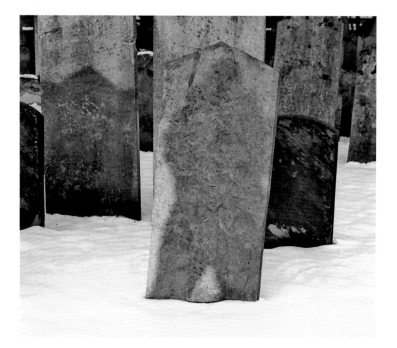